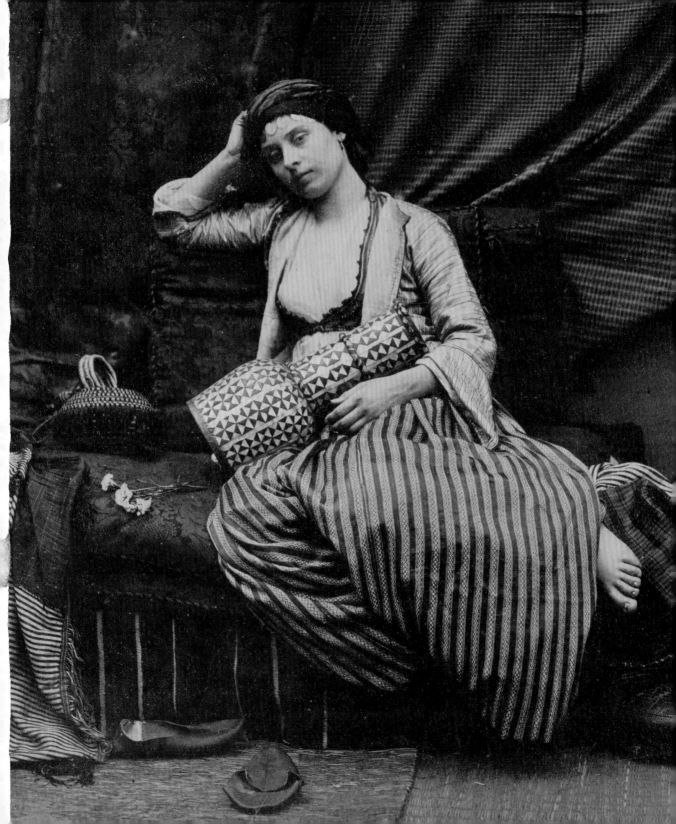

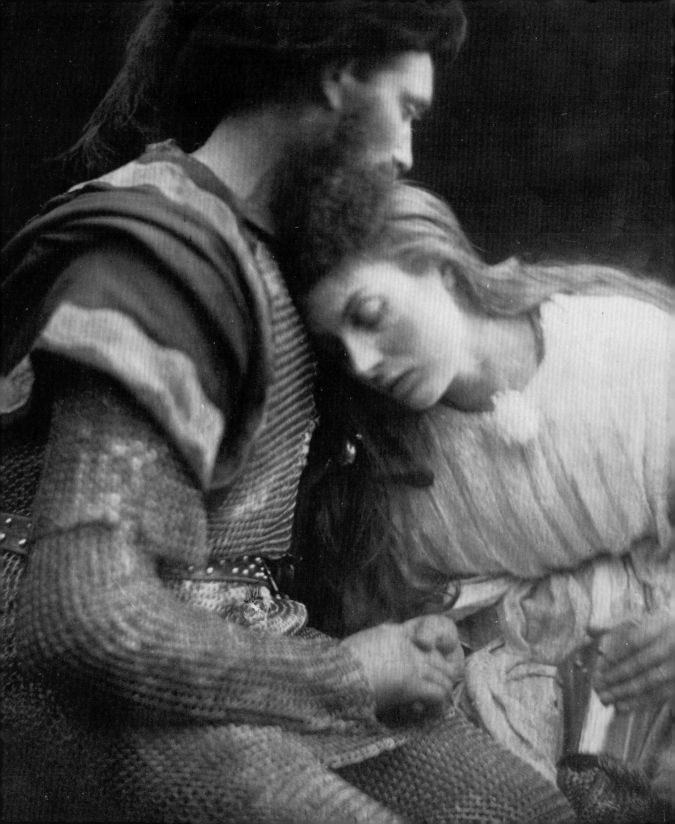

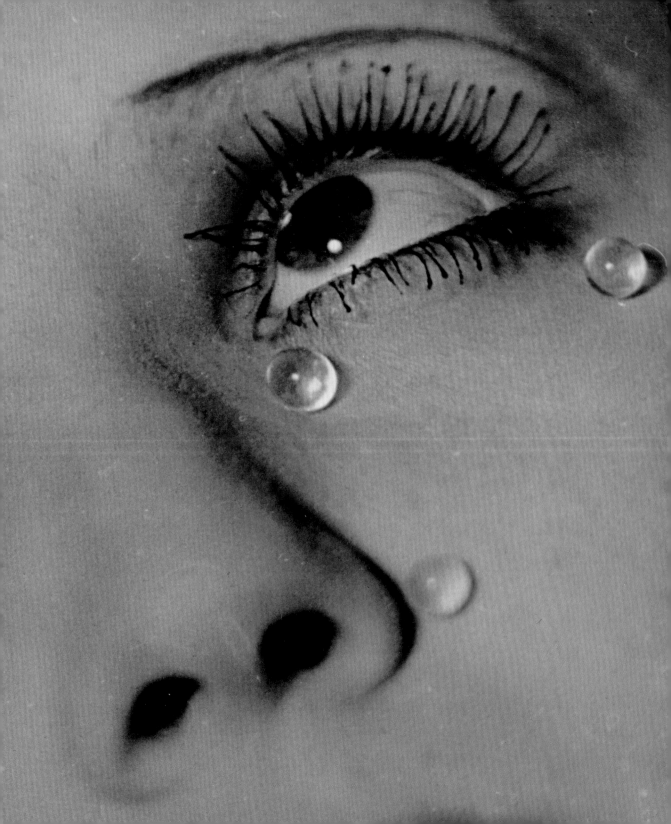

Erin C. Garcia

PHOTOGRAPHY AS
Fiction

The J. Paul Getty Museum, Los Angeles

Photography is commonly associated with fact, yet it has been a medium for fiction from the very beginning. Since its inception in 1839, artists have explored photography's vast creative potential, which included the capacity to convey deliberately crafted "untruths." Stage productions and the Victorian parlor game of tableau vivant (living picture)—in which costumed participants posed to resemble famous works of art or literary scenes—offered ready models for constructing narrative pictures. The camera conveniently arrested action and stood in for the live audience. Indeed, the camera became a substitute for the darkened room of the theater.

Over the course of photography's history, the acceptance of staging—and the degree to which it has been applied in the creation of the work—has varied greatly depending on the moment and the particular genre. Staged photography has come to encompass a broad range of things, from elaborate fabrications to the subtle manipulation of images that appear to be purely reportorial. It is staging as an expressive approach, and the persistence of that approach from photography's inception to the present day, that is the subject of this book. The images that follow span photography's history, utilize diverse styles and techniques, and convey a range of different sentiments. Some rely on props and stagecraft for effect, others use darkroom trickery to communicate directly from the imagination. What they share is a lack of pretense about documenting the everyday world. Instead, they embrace the myriad possibilities of making a scene expressly for the camera.

The plates in this book are drawn exclusively from the Getty Museum's holdings; the selection reflects a collection that is rich in American and European material, while also including some examples from East Asia. Rather than presenting a comprehensive review, the chosen works illustrate some notable episodes from the history of staged photography. Although it was tempting to put thematically similar pictures side by side—and there are interesting kinships that slice across time—the plates are, for the most part, arranged chronologically to emphasize how creating something for the camera played into photography's larger narratives. Staging was useful at certain moments, and it figured into some of photography's most contentious debates.

Technological limitations prevented early photographers from making spontaneous images. Out of necessity, pictures of people were always staged to some degree. Portrait studios were carefully outfitted to maximize lighting conditions and to keep sitters perfectly still. Discreet iron head braces held subjects in place from behind. To counter the stilted poses and impersonal settings, it was common for people to appear with props that revealed something of their identity or occupation. Occasionally, sitters gave small performances for the camera, gesturing amid carefully staged sets—pretending to work, perform domestic chores, or read.

Some photographers took the staged portrait one step further, creating scenes that conveyed more ambitious narratives. This was especially so among a number of photographers working in the United Kingdom in the middle of the nineteenth century. From 1843 to 1847, David Octavius Hill and Robert

Adamson produced a remarkable group of portraits that included some of the earliest photographs conceived as fine art. Hill, a painter hired to commemorate the men who formed the Free Church of Scotland, teamed up with Adamson to make photographic studies of his subjects. The task took on a life of its own. The pair began making illustrative works, staging scenes from Sir Walter Scott's novel *The Antiquary,* for example (plate 11). Other pictures appear to record the costumed participants of actual tableaux vivants, which Hill was known to have produced for parties.[1] In compositions they made at Greyfriars Churchyard in Edinburgh, Scotland, Hill and Adamson borrowed elements from stage productions, posing figures in front of the backdrops created by ornate funerary monuments (plate 10).

Hill and Adamson used atmospheric lighting and the soft, granular properties of the early paper negative process to great advantage, and their photographs were lauded as the most picturesque examples of the new medium.[2] Nonetheless, the question of whether a photograph could be art was very much up for debate. Many believed that no matter how noble the subject matter, or how elegantly produced the image, photographs could only ever be useful as tools and could never stand as works of art in their own right. Oscar Gustave Rejlander visually summarized the discussion in his allegorical photograph *The Infant Photography Giving the Painter an Additional Brush* (plate 16). The image is constructed like a still life, in which a cupid rests on a camera and hands a new brush to a mature painter in exchange for a golden coin. With its references to classicism and traditional academic painting, the picture suggests that photography merely serves the established arts. Rejlander and his camera appear in the mirror, reminding viewers of photography's precise, and problematic, reflection of nature.[3]

The debate hinged on the perceived incompatibility of artistry—in both technique and expression—with the camera's blunt factuality. The camera

so effortlessly replicated nature that photographers were seen as nothing more than machine operators. Therefore, photographers who wanted to be perceived as professional artists and taken as seriously as painters had to find ways to assert themselves artistically and intellectually.

The photographer Henry Peach Robinson wrote that "a method that will not admit of the modifications of the artist cannot be an art."[4] Robinson, who started as a painter, became famous for his seamlessly constructed composite photographs such as *When the Day's Work Is Done*, an allegory about the cycle of life (plate 17). To create the large-scale picture, he meticulously set up scenes using props and models, lit and photographed each plane, then fitted together several different negatives like the pieces of a puzzle. The cumbersome technique, which presaged twentieth-century photomontage, yielded a picture that was entirely the artist's creation but maintained a convincing illusion of reality. Robinson published the details of his technique in photographic treatises and was disappointed to find that the public felt deceived by his combination prints. He ultimately posited that it was better for an artist to take credit for the finished product without revealing his methods.[5]

Other photographers, like Julia Margaret Cameron and Lewis Carroll, had little stake in construing photography as an artistic profession; to the contrary, both considered themselves amateurs and, as such, were much less concerned than Robinson with creating highly polished, seamlessly constructed pictures. The artificiality of Cameron's tableaux was readily apparent in the overwrought state of her subjects, the crudeness of her stagecraft, her inclusion of well-known public figures as models, and the reappearance from one picture to the next of members of her household. Take, for example, *Elaine* (plate 21), a picture she made as part of a series illustrating Alfred Tennyson's *Idylls of the King*, a book of poems that retell the Arthurian legend. Cameron's husband posed with an unknown woman in a boat,

indoors, before both a folding screen painted with a landscape and a tapestry strung awkwardly from the ceiling. What Cameron staged was not the scene from the poem, which takes place on a river, but a homespun production of the scene from the poem. Cameron brought the same unselfconscious artificiality to religious subjects, such as *Une sainte famille (A Holy Family)* (plate 23), a picture of a woman and children from her household. Cameron did not mean for pictures like these to be taken literally —as a vision of the actual holy family—but rather to evince a connection between the natural realm of her human subjects and the spiritual realm.

Charles Lutwidge Dodgson, known better by his pen name Lewis Carroll, made even less of an effort to conceal the artifice of his photographic tableaux, and often the effect is somewhat iconoclastic. In *Saint George and the Dragon* (plate 25), he staged a production based on the legend of Saint George, patron saint of England. As the story goes, George slew a child-eating dragon before it could devour a princess, then married the rescued princess and converted her pagan town to Christianity. Dodgson cast children in the starring roles, posed the heroic figure on a rocking horse, and cloaked the beast in a bearskin rug. Without diminishing the moral, Carroll transformed a subject of serious paintings into a fairy tale.

The threads of debate about photography's relationship to fine art that began in the nineteenth century resonated well beyond the Victorian era. At the turn of the twentieth century, the work of Robinson, Cameron, and Hill and Adamson was especially influential for Pictorialist photographers who, in their struggle to define photography as a legitimate art form, sought an artistic lineage.[6] Much like their Victorian counterparts, the Pictorialists adopted the subject matter of paintings but, unlike the Victorians, they were much less concerned with being true to nature than they were with creating expressive and subjective images.

In the years around 1900 it was more important than ever for artistic photographers to distinguish themselves. Advances in technology and manufacturing made photography commonplace in commercial applications and increasingly accessible to ordinary people in the form of handheld cameras and roll film. Pictorialist photographers sought to distance themselves from the financially motivated professional ranks on the one hand and from unsophisticated snapshooters on the other. The aesthetic dialogues of the day valued the handcrafted work and prescribed that art strive to express emotions, ideals, or spiritual truths. Pictorialist photographers used handmade printing methods, such as gum bichromate, platinum, and bromoil, and altered their photographs with color or brushwork. They also pursued suitably elevated subject matter, which sometimes exceeded what was typically visible in the real world. Staging proved useful in this regard.

Consider, for example, Gertrude Käsebier's shadowy portrait of a woman and child titled *The Manger (Ideal Motherhood)* (plate 26). Käsebier was part of the vanguard of American Pictorialism and was herself a mother. Using a transparent veil and robe, she transformed a woman (the illustrator Frances Delehanty) into a Madonna figure holding an infant (nothing more than a bundle of fabric).[7] In terrain explored extensively by Cameron, Käsebier expressed her great reverence for Christianity and maternity but took much greater care than Cameron in seamlessly constructing her picture. The scene is entirely absent of amateurish props and distracting details; even the identity of the model is concealed, her face hidden in shadows, so that she becomes an archetypal figure. The simple geometry of the stable stall in the background reflects the prevailing Arts and Crafts sense of design. Carefully orchestrated lighting and soft focus give the effect of an Impressionist painting, and the final print was expertly done in velvety platinum. In recasting and updating the traditional Madonna and Child painting as a photograph in the aesthetic vocabulary of her day,

Käsebier meant to be taken seriously as an artist.[8]

The extent to which Käsebier brought her own sensibility to a traditional subject of painting is clear when one compares her work to that of the Italian photographer Guido Rey. Rey became fascinated with the genre paintings of the seventeenth-century Dutch masters Johannes Vermeer and Pieter de Hooch. He carefully studied their work and then arranged similar tableaux for his camera. *The Letter* (plate 33) and *Dutch Interior* (plate 34) captured serene domestic scenes and re-created minute architectural details of seventeenth-century interiors, such as leaded glass windowpanes and checkerboard floors. Rey was remarkably unselfconscious in his mimicry, for within the Pictorialist idiom, imitating painting was regarded as a suitable path for creating artistic photography. At least Alfred Stieglitz thought so—as leader of the American Photo-Secessionist movement and champion of Pictorialist photographers like Käsebier, Stieglitz published photographs by Rey in his influential journal *Camera Work*.[9]

Other photographers looked more generally to art of the past. Classicism held great expressive potential for those Pictorialist photographers drawn to the origins of Western culture but perhaps uninterested in Christianity. Classicism also offered the highest possible moral reasons for studying the nude figure. Baron Wilhelm von Gloeden, a German photographer who settled in a coastal town in Sicily, photographed young local boys in classical compositions that often held erotic interest. Rather than reenact specific historical or literary scenes, he mused about the Greek and Roman ancestry of his models in tableaux such as *Untitled (Two Youths Holding Palm Fronds)* (plate 27).[10] This interest in ancient cultures also existed within the broader aesthetic movements in Europe and America that responded to industrialization by looking nostalgically to an idealized, arcadian past. In this imagined refuge, life was perceived to be simpler and more natural than in the modern world. Certainly von Gloeden found creative and personal refuge far from the urban centers of the art world.

While Pictorialism aimed to raise photography's status by emulating painting and other art forms, individuals working under the movement's broad umbrella often had more personal goals. Anne W. Brigman used the soft-focus style and vague references to classicism popular among Pictorialists to create her own vision of the world. In rugged natural settings, she staged scenes with female models (sometimes Brigman herself) posing nude. By disrobing outdoors, the women defied social convention; Brigman's photographs have thus been read as expressions of her desire for personal liberation.[11] In *The Heart of the Storm* (plate 35), printed in 1914, a wizened pine in California's Sierra Mountains provides a backdrop to a mystical scene. A woman in gauzy drapery cowers next to a nude figure whose head is surrounded by light. The stormy atmosphere and the glowing halo—both created by manipulating the print in the darkroom—suggest emotional tumult and spiritual enlightenment. Like von Gloeden, Brigman created a scene that looked to an imaginary past, using references to antiquity and nature. She also posited an idealized and empowering future.

Despite the unique contributions of individual artists, Pictorialism coalesced into a set of conventions that would soon seem excessively mannered and overwrought with symbolism. By the 1920s, photographer William Mortensen had taken Pictorialist staging and darkroom manipulations to a new level. As a scenic designer and still photographer for Hollywood productions, his gothic tableaux drew imagery from silent films. In works such as *The Bad Thief* (plate 36), made on the set of director Cecil B. DeMille's *King of Kings*—a film about the Passion of Christ—Mortensen availed himself of cinema's preproduction costuming, makeup, props, and lighting. Mortensen not only eschewed the poetry and allegory of earlier Pictorialism but also depicted his provocative fantasy scenes in a manner more heavy-handed and graphic than anything that had come before. In his extensive writings he

railed against realism, touted the virtues of combining images, and advocated applying handwork to get desired effects.

Partly because he was so outspoken, Mortensen became a target of contempt in the discussion surrounding the sentimentality and staginess of Pictorialism. Members of Group f/64, an informal society of Northern California photographers, engaged Mortensen in debate in a series of statements and letters published in *Camera Craft* magazine in the 1930s.[12] The members of Group f/64 considered themselves Modernists and, as such, advocated an aesthetic defined by sharp focus, straight (or unmanipulated) prints, and subject matter drawn from the real world. A tongue-in-cheek tableau they staged in the early 1920s, titled *Saint Anne of the Crooked Halo* (plate 37), summarized their new disdain for Pictorialism. Brigman, who made her career a decade earlier as a Pictorialist, poses as a saint to whom her fellow photographers, including Edward Weston and Imogen Cunningham, pray in mock seriousness. The picture is one of a series taken during a party in the home of one Group f/64 member. While the

photograph reflects the prevailing ethos of the group, in reality many Group f/64 photographers had only recently begun to shed the soft-focus, atmospheric style of the Pictorialist photography they mocked. Their counterparts on the East Coast, namely Stieglitz and Paul Strand, had been making objective, sharply focused pictures since the 1910s.

The line between staged and straight photographs—for that matter, between Pictorialism and Modernism, or between the worlds of commerce and art—was not so distinct. Pictorialist photography, including images of scenes created expressly for the camera, persisted well into the twentieth century among amateurs affiliated with regional camera clubs. Proponents of straight photography, namely Stieglitz and Weston, often set up the subjects they photographed—take Weston's carefully posed *Nude* (fig. 1), for example, or Stieglitz's 1918 portraits of his future wife, the painter Georgia O'Keeffe, who gestures provocatively with her powerful hands (plates 38, 39). Nevertheless, by the 1920s, elaborate staging was the standard of the advertising, fashion, and entertainment industries. This association undoubtedly made the practice of staging distasteful to photographers who wanted to be perceived as unencumbered by commercial concerns. This was especially true in the United States, where straight photography and its close relative, the socially engaged documentary photograph, predominated during the 1930s and beyond.

During the interwar period in Europe, Modernist photography took experimental directions. Avantgarde artistic movements, such as French Surrealism, encouraged artistic experimentation as part of a more general effort to engage the public politically through visual media. Photographers used techniques such as collage and montage; they constructed scenes, induced colleagues to playact, and introduced props into their photographs. The results were hardly narrative tableaux vivants, reimagined for the twentieth century, but instead reflected a more conceptual approach to picture making. Staging, as

FIGURE 1. Edward Weston (American, 1886–1958), *Nude*, 1923. Gelatin silver print, 15.4 × 21 cm (6¹⁄₁₆ × 8¼ in.). Los Angeles, J. Paul Getty Museum, 85.XM.257.2

it was employed in these photographs, also brought with it a notable change in sentiment. Whereas Pictorialist photographers used costumes and props to depict subjects worthy of veneration, in twentieth-century avant-garde photography, staging was often used to irreverent or subversive ends.

The Surrealist movement produced much of Modernism's contribution to the field of staged photography. Man Ray, a leading Surrealist artist who worked in France and the United States, made tableaux vivants of various sorts throughout his career. Influenced by Dada, a movement that rejected reason and logic in favor of anarchy and the absurd, Man Ray embraced games of chance, performance, and wordplay in his work. Playacting also figured prominently in his compositions. In 1923, he photographed French artist Marcel Duchamp in women's clothing as Duchamp's breezy, female alter ego, Rrose Sélavy, whose name is a pun on the phrase *Eros, c'est la vie* (Eros, that's life) (plate 40). The photograph was facetious and lighthearted but also transgressive in its gender role reversal. In another work, *Larmes (Tears)* (plate 41), Man Ray emulated the melodrama that compensated for the lack of dialogue in silent films. His starlet gazed upward in a plaintive expression of distress as her mascara-encrusted eyes seem to shed perfectly round teardrops (made of glass). The extreme close-up caused a visual metamorphosis, transforming the woman's eyes into insect-like creatures with hundreds of legs. The photograph suggested the narrative of the desirable but dangerous femme fatale.[13]

Ironically, it was photography's unique relationship to the real world that made it an appealing tool for exploring the realm of the surreal. Mechanical and presumably undiscriminating, photography was perceived to be unencumbered by rational thought and therefore open to the creative possibilities of both happenstance and the eruptions of the psyche. Although the Surrealists applauded automatism, a process in which the artist abdicated conscious control, they often in fact went to great lengths to construct their imagery. Take, for example, Dora Maar's dreamscape *Le simulateur (The Pretender)* (plate 45). Like Robinson, Maar created this fantastical montage from multiple images. She combined a photograph of a vaulted corridor, deliberately turned upside down, with that of a boy arching his back unnaturally. She then rephotographed the collage to create a seamless final image. The dungeon-like netherworld that resulted could be read as a tableau of the irrational unconscious mind.

Surrealism's influence outside of Europe was extensive, with photographers as far away as Japan adopting Surrealist imagery. In the United States, Surrealism first found its way into advertising and fashion photography in the 1930s through avant-garde artists like Man Ray, who also did magazine work. With the onset of World War II, Man Ray and a number of European artists, including Salvador Dalí and Max Ernst, settled in the United States. No longer tied to the revolutionary politics of Europe, Surrealism in America became a means for self-exploration. Clarence John Laughlin and Ralph Eugene Meatyard used photography to stage psychologically charged tableaux (fig. 2). Meatyard's photographs appeared to be ordinary scenes of his children, friends, and neighbors, but uncanny details imbued them with the qualities of a dream. In *Life of Aspersorium* (plate 54), his two sons pose in what looks like an abandoned house. Between them, a gravity-defying pile of fabric rises from the floor beneath a chandelier that resembles an aspersorium (a vessel for holy water). To achieve his supernatural visions, Meatyard used experimental techniques such as motion blur and multiple exposures. In another image of his sons, one of the boys appears to hover in midair like an angelic apparition (plate 56). Like contemporary painters René Magritte and Ben Shahn, Meatyard investigated the strangeness that existed just below the surface of everyday life instead of trying to map an exotic unconscious.

Despite the persistence of artists like Meatyard, staged photography received little critical attention

what constituted an art photograph. They took the medium in hundreds of new directions.

Conceptual art of the 1960s and '70s was particularly relevant to contemporary staged photography. Rebelling against the rarified context in which art was received and against the art object's commodity status, conceptual artists created installations, performances, body art, and happenings—all of which were typically staged outside the traditional gallery or museum and impervious to marketing. Photographs were often the only surviving visual record of these ephemeral artworks—take, for example, Joseph Beuys's *Bog Action*, a performance he staged in a remote marsh to draw attention to the preservation of wetlands, which was photographed by Gianfranco Gorgoni (fig. 3). Eventually, such photographs were themselves imbued with the status and value of art objects and became the end point of conceptually driven practices. The camera, once again, stood in for the live audience.

The Polaroid camera was particularly popular among artists who wanted to stage scenes in private. The Polaroid required no technical expertise in photography and produced instantaneous, self-developing color snapshots with the click of a button. Lucas Samaras, who had been working as a performance artist, began obsessively photographing himself with a Polaroid in the 1970s. In his series Photo-Transformations, he appeared in the kitchen of his New York apartment in various guises. In a 1976 work (plate 59), he used multiple exposures to appear as both the biblical Judith beheading Holofernes and as the beheaded Holofernes himself. In a picture from 1974 (plate 58), he used a stylus to manipulate the undeveloped dyes in the Polaroid film to create an expressionistic image of his body dissolving into the background.

Samaras's project was a thorough investigation of his own psyche, and many of his contemporaries also put themselves at the center of their work. Andy Warhol collaborated with Christopher Makos to make *Self-Portrait (in Drag)* (plate 60), one of a series of

in the United States in the mid-twentieth century. The Great Depression, World War II, and anticommunist sentiment all had an indelible impact on the priorities of artists and historians in the postwar period. Straight or documentary photographs, which presented themselves as plainspoken and apolitical, were lauded, while other practices were largely ignored. It was not until writer A. D. Coleman inveighed against history's bias toward straight photography in his 1976 *Artforum* essay, "The Directorial Mode: Notes Toward a Definition," that the oversight was acknowledged.[14] Coleman's essay marked a turning point in scholarship on photography, but its publication also coincided with new interest among contemporary artists in using the camera. Coming from outside the field of photography, these artists were not invested in the medium's long-standing traditions and debates about

FIGURE 2. Clarence John Laughlin (American, 1905–1985), *Figure with Phantasmal Fan*, 1941. Gelatin silver print, 26.6 × 21.7 cm (10½ × 8⁹⁄₁₆ in.). Los Angeles, J. Paul Getty Museum, 84.XM.727.39

Polaroids picturing Warhol dressed as a woman. The series was inspired by Man Ray's 1920s portraits of Duchamp as Rrose Sélavy (see plate 40). Warhol and Makos hired a theatrical makeup artist to transform Warhol's face into a woman's, and Warhol appeared in various wigs and costumes. Although the pictures were ostensibly about Warhol's ambiguous sexuality, they, unlike Samaras's work, dealt mainly with appearances and external identity. Warhol was interested in the way images functioned in the world, and his self-portraits reference mainstream fashion magazines and celebrity photographs.

The proliferation of photographic images through film, television, and advertising became a primary subject for many contemporary artists using photography in the 1970s and '80s. Although not represented in the Getty Museum's collection, Cindy Sherman was extremely influential, and her Untitled Film Stills series bears noting (fig. 4). The photographs picture her posing as stereotypical film noir characters. Nearly unrecognizable in each of her different guises, Sherman posited that personal identity might be nothing more than a series of impersonations or performances.[15] Sherman's Film Stills stood at the intersection of some of contemporary photography's most fruitful avenues of investigation. In the most general sense, they participated in larger cultural examinations of the authenticity of contemporary experience and the concept of reality itself.

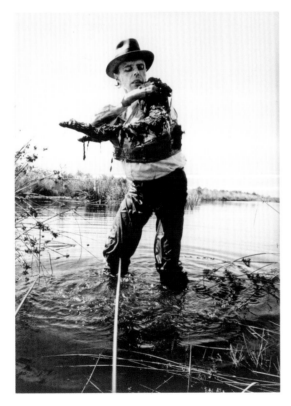

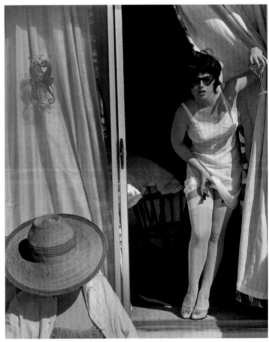

FIGURE 3. Gianfranco Gorgoni (Italian, b. 1941), *Joseph Beuys Standing in Mud, Eindhoven, Netherlands*, 1971. Gelatin silver print, 30.8 × 20.8 cm (12⅛ × 8³⁄₁₆ in.). Los Angeles, J. Paul Getty Museum, 2001.37.26

FIGURE 4. Cindy Sherman (American, b. 1954), *Untitled Film Still*, 1978. Gelatin silver print, 25.4 × 20.3 cm (10 × 8 in.). Courtesy of the Artist and Metro Pictures

Contemporary artists addressed these concerns in diverse ways throughout the 1980s and '90s. At a time when cultural politics in America centered on the family, many photographers turned their attention to the domestic sphere. Sandy Skoglund's large-scale color photographs are hyperreal tableaux of domestic scenes gone awry. In *Revenge of the Goldfish* (plate 62), a couple's nighttime bedroom becomes an aquarium overrun with oversized goldfish. The photograph presents a humorous but also anxious vision of a radioactive contemporary world. In a photograph by Jo Ann Callis titled *Performance* (plate 65), a woman stands on her hands wearing a dress and heels, a metaphor for the balancing act contemporary women undertake.

Other photographers addressed the complexities of contemporary family life more directly. In her series Family Docudrama, Eileen Cowin staged domestic scenes in which she and members of her family, including her identical twin sister, performed as actors (plates 66–69). Like Sherman, Cowin blurred the boundaries between truth and fiction, and between private behavior and public performance, by adopting the lens of mainstream media. Her photographs drew as much from family snapshots as they did from soap operas. As in daytime television, the story unfolds in serial form, but the specifics of the dramas remain open ended. Unnatural lighting and stilted gestures remind viewers that the pictures are set up. When Cowin and her sister appear together, one seems to stand in for the psyche of the other. Cowin's appearance also adds a layer of critical distance: she participates in the drama but also orchestrates it from behind the camera.

The image-saturated world of the mainstream media provided a hall of mirrors in which many artists cast their critiques of contemporary culture. For others, the art world itself became the stage for concerns about social inequities. In his painstaking re-creations of canonical works of Western art history, Yasumasa Morimura delves into issues of race, sexuality, and the biases of the Western

art world. In chameleon-like transformations, the artist himself, a gay Japanese man, appears in the unlikeliest of roles. Take, for example, *Theater A* (plate 71), from his series Daughter of Art History. Here Morimura poses as the barmaid in Édouard Manet's famous painting *A Bar at the Folies-Bergère* (1882), with his bare arms emerging from the bodice of the dress. In the photograph's nearly identical pendant, *Theater B* (plate 72), Morimura appears nude with a vase in front of his genitals. He achieves these bravura works using makeup, costumes, props, photomontage, and digital imaging software, as well as acrylic lacquer that mimics the effect of brushstrokes. By placing himself in the center of iconic works of art, as both the artist and the model, Morimura empowers himself as author as well as object of desire.

Carrie Mae Weems is similarly concerned with the way Western art has treated nonwhite subjects. In her suite of photographs May Days Long Forgotten, she stages scenes with girls from a working-class family in her Syracuse, New York, neighborhood. Like all of Weems's work, the photographs reference history, art, African American cultural identity, class, and gender. Enclosed in carefully chosen circular frames, they immediately bring to mind late-nineteenth-century art, specifically Cameron's reverential portraits of the women and children of her household. In *May Flowers* (plate 75), Weems recasts healthy, self-possessed black girls in the roles of Cameron's ethereal British maidens. Where Cameron's subjects wore yielding, complacent expressions, Weems deliberately photographs her subjects in thought or staring directly into the camera. Although crowned with flowers, like Cameron's imaginary Madonnas and goddesses, these are real girls and not characters from literature or history.

Contemporary photographers like Weems and Morimura ask us to look back to the art of the nineteenth century. In doing so, we find many connections to the present and can look anew at what went before. Through the lens of Morimura's

ironic re-creations of masterworks, Rey's imitations of seventeenth-century Dutch paintings appear charmingly sincere. The lineage of Cowin's serial family dramas stretches as far back as Robinson's domestic genre scenes. Like artists in other media, photographers have always looked to the art of the past for inspiration. Käsebier and Cameron reimagined early Christian art for their times; others, such as von Gloeden, looked back to antiquity.

Nevertheless, the context and meaning of staged photographs have changed drastically over the course of photography's history. At certain moments, the practice seemed retrograde in one country, while it was perceived as avant-garde in another. Time and again, the stage has been reconstructed. The amateur theater of the Victorian tableau vivant has been reimagined on an infinite number of new platforms. Nature, the subconscious, abandoned buildings, home, and the performance space created by art itself are a few examples. These stages represent not just changes in scenery, but shifting conceptions of what the very deliberate act of creating something for the camera means.

NOTES

1 Colin Ford, *An Early Victorian Album: The Photographic Masterpieces (1843–1847) of David Octavius Hill and Robert Adamson* (New York, 1976), pp. 32–34.

2 Lady Elizabeth Eastlake, *The Quarterly Review* no. 101 (March 1857), as quoted in Ford, *Victorian Album*, p. 4.

3 See Steve Edwards, *The Making of English Photography: Allegories* (University Park, Pa., 2006).

4 Henry P. Robinson, "Paradoxes of Art, Science, and Photography," *Wilson's Photographic Magazine* 29 (1892), pp. 242–45. For more on Robinson, see Ellen Handy, *Pictorial Effect Naturalistic Vision: The Photographs and Theories of Henry Peach Robinson and Peter Henry Emerson* (Norfolk, Va., 1994).

5 Malcolm Daniel, "Darkroom vs. Greenroom: Victorian Art Photography and Popular Theatrical Entertainment," *Image* 33, nos. 1–2 (Fall 1990), pp. 13–19.

6 Alfred Stieglitz promoted the work of Victorian photographers in his influential journal *Camera Work*, publishing nineteenth-century pictures alongside pictures by contemporary Pictorialist photographers. Several photographs by Cameron appeared in a 1913 issue (no. 41); work by Hill and Adamson appeared in three issues between 1905 and 1912 (nos. 11, 28, and 37). See also Marianne Fulton, ed., *Camera Work: A Pictorial Guide* (New York, 1978).

7 Barbara L. Michaels, *Gertrude Käsebier: The Photographer and Her Photographs* (New York, 1992), p. 55.

8 For more on Christian art at the turn of the twentieth century, see Kristin Schwain, *Signs of Grace: Religion and American Art in the Gilded Age* (Ithaca, N.Y., 2008).

9 Stieglitz published two of Rey's photographs, including *The Letter*, in *Camera Work*, no. 24 (1908).

10 See Jason Goldman, "Nostalgia and the Photography of Wilhelm von Gloeden," *GLQ: A Journal of Gay and Lesbian Studies* 12, no. 2 (2006), pp. 237–58.

11 Sally Stein, "Starting from Pictorialism: Notable Continuities in the Modernization of California Photography," in *Capturing Light: Masterpieces of California Photography, 1850 to the Present*, edited by Drew Johnson (Oakland, Calif., 2001), p. 123.

12 Therese Thau Heyman, ed., *Seeing Straight: The F.64 Revolution in Photography* (Oakland, Calif., 1992), pp. 52–64.

13 For more on Man Ray and Surrealism, see Rosalind E. Krauss, ed., *L'Amour Fou: Photography and Surrealism* (New York, 1985).

14 A. D. Coleman, *Light Readings: A Photography Critic's Writings 1968–1978* (New York, 1979), p. 246. Coleman's essay was originally published in *Artforum* 15, no. 1 (September 1976), pp. 55–61.

15 For more on Sherman and Postmodernism in photography, see Andy Grundberg, "Crisis of the Real: Photography and Postmodernism," in *Multiple Views: Logan Grant Essays on Photography 1983–89*, edited by Daniel P. Younger (Albuquerque, N.M., 1991), pp. 363–85.

SUGGESTIONS FOR FURTHER READING ON THE TOPIC OF STAGED PHOTOGRAPHS

Dines-Cox, Elaine K. *Anxious Interiors: An Exhibition of Tableau Photography and Sculpture.* Laguna Beach, CA, 1984.

Edwards, Kathleen A. *Acting Out: Invented Melodrama in Contemporary Photography.* Iowa City, 2005.

Hoy, Anne H. *Fabrications: Staged, Altered, and Appropriated Photographs.* New York, 1987.

Kohler, Michael. *Constructed Realities: The Art of Staged Photography.* Zurich, 1995.

Pauli, Lori. *Acting the Part: Photography as Theatre.* London and New York, 2006.

PLATES

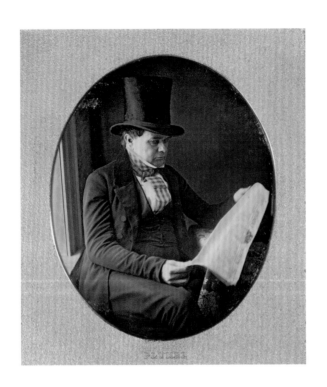

1 **JOHN PLUMBE JR.**
Portrait of a Man Reading a Newspaper, ca. 1842

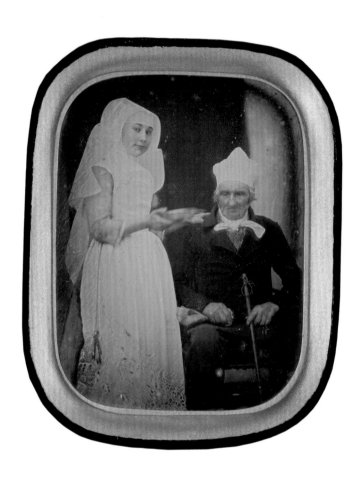

2 **UNKNOWN FRENCH PHOTOGRAPHER**
A Sister of Charity Serving a Patient at the Hospice de Beaune,
ca. 1848

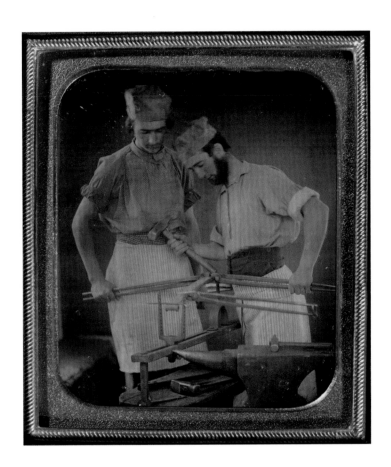

3 **UNKNOWN AMERICAN PHOTOGRAPHER**
Two Metalworkers, 1855

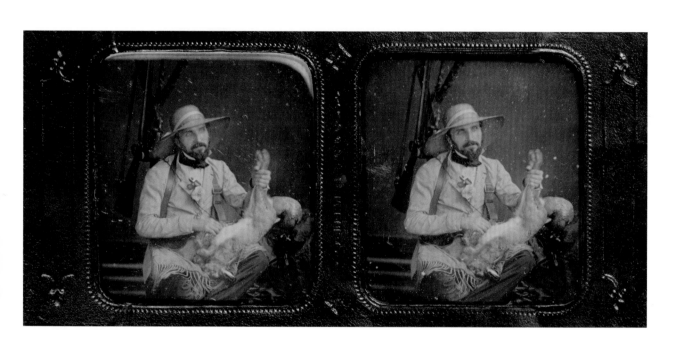

4 **WARREN T. THOMPSON**
Self-Portrait as a Hunter, ca. 1855

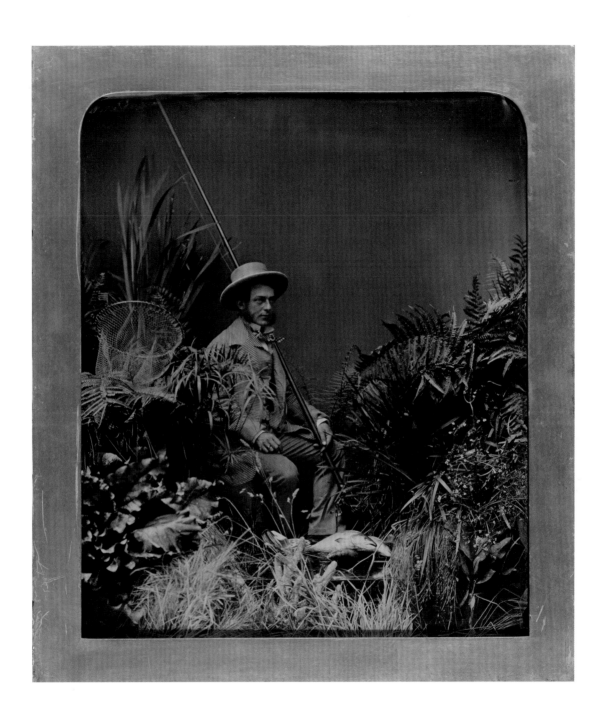

5 UNKNOWN BRITISH PHOTOGRAPHER
Man Posed with Fishing Gear, ca. 1860

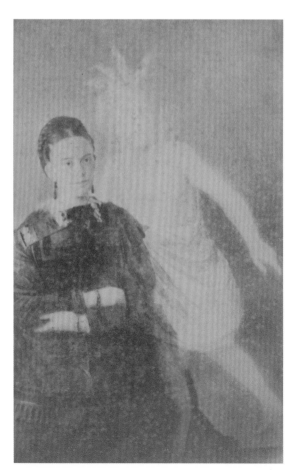

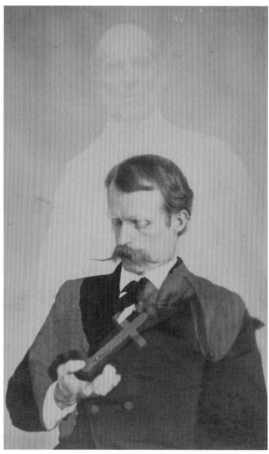

Some believed Boston photographer William H. Mumler when he claimed he could photograph spirits. The nineteenth-century religious movement known as Spiritualism fostered interest in such supernatural phenomena, and its proponents used the rhetoric of science to bolster their beliefs. Photography seemed the ideal instrument to prove the existence of spirits, for it had the capacity—in microscopic images and X-rays, for example—to picture things that were invisible to the naked eye.

Mumler's skeptics sought to prove him a fraud, and a court trial ensued in 1869. Expert witnesses described how Mumler could have staged the ghostly illusions, including allowing a person to briefly enter the picture during exposure, exposing a negative twice, and combining multiple negatives in the darkroom. Other photographers at the time, most notably Oscar Gustave Rejlander and Henry Peach Robinson, were using these very same techniques for artistic effect. By the twentieth century, what was once considered darkroom trickery would be embraced as avant-garde experimentation.

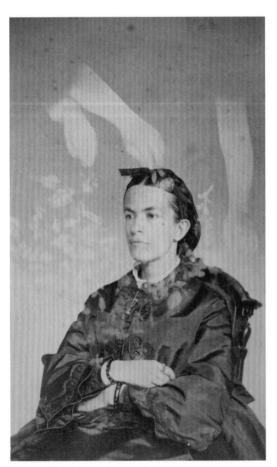
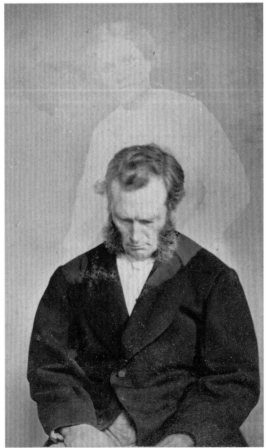

10 DAVID OCTAVIUS HILL
ROBERT ADAMSON
Greyfriars Churchyard, the Dennistoun Monument
with D. O. Hill and His Nieces, 1843–47

11 DAVID OCTAVIUS HILL
ROBERT ADAMSON
Mrs. Elizabeth Cockburn Cleghorn and John Henning
as Miss Wardour and Edie Ochiltree from Sir Walter Scott's
The Antiquary, 1846–47

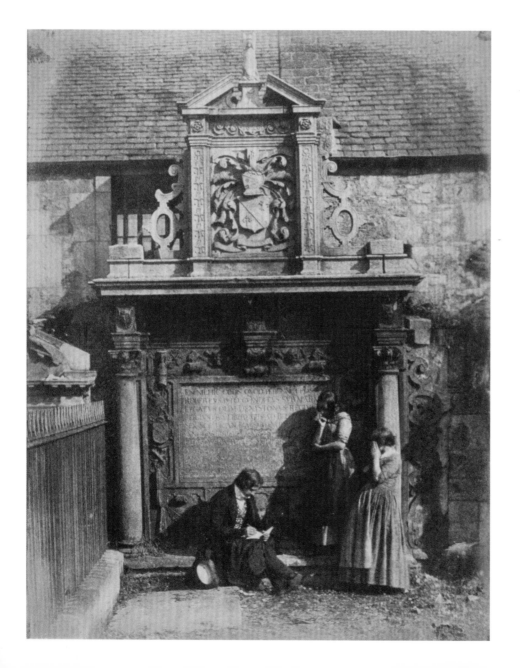

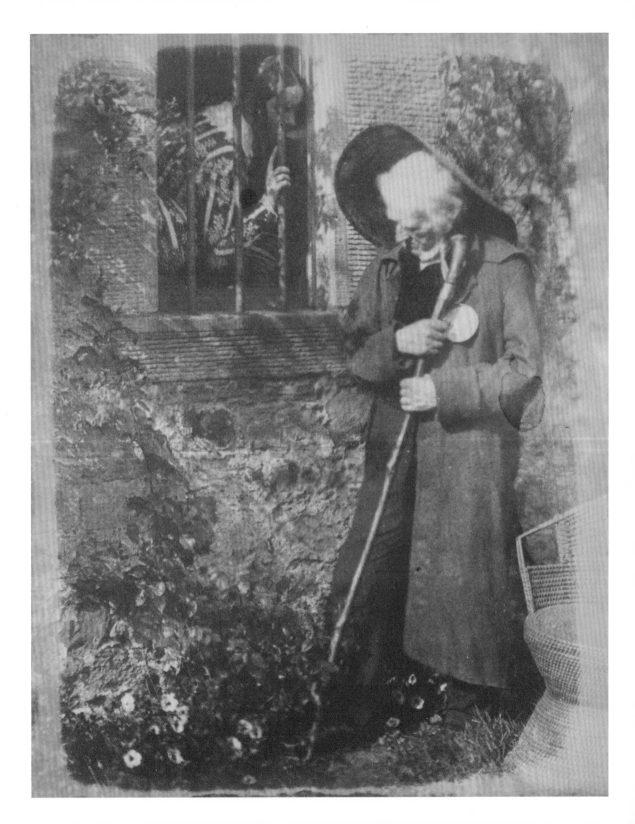

Roger Fenton made a suite of fifty-one Orientalist pictures in his London studio, having found inspiration in the work of nineteenth-century French painter Eugène Delacroix and his contemporaries. Fenton had been to the Near East as a photographer of the Crimean War (1854–56), but his Orientalist suite did not document or re-create his actual observations. Rather, his fictional scenes conjured an exotic but nonspecific Islamic culture, in which he imagined social mores to be tantalizingly less restrictive than in the West.

Careful examination of Fenton's *Pasha and Bayadère* (plate 14) reveals its inauthenticity. The artifacts look staged and incongruous beneath the skylight in Fenton's London studio, and there is a quality of suspended animation to the figures— notice, for example, the wires holding the dancer's raised arms in place. Photographic chemistry at the time was not sensitive enough to capture movement, so Fenton's models had to be perfectly still for the exposure.

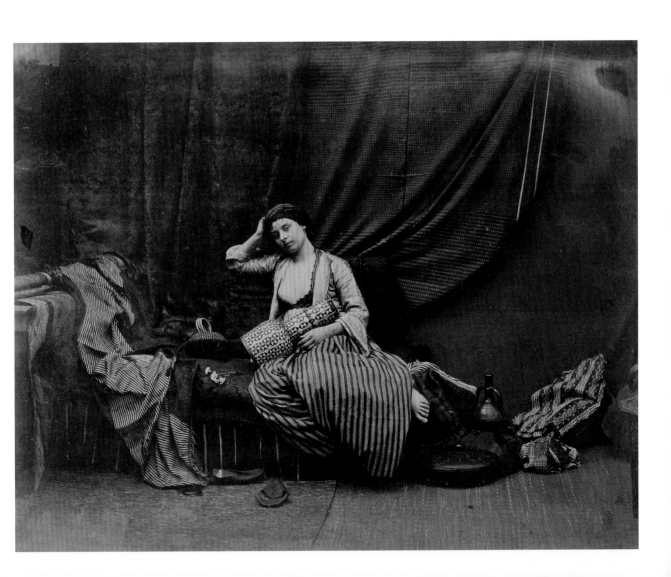

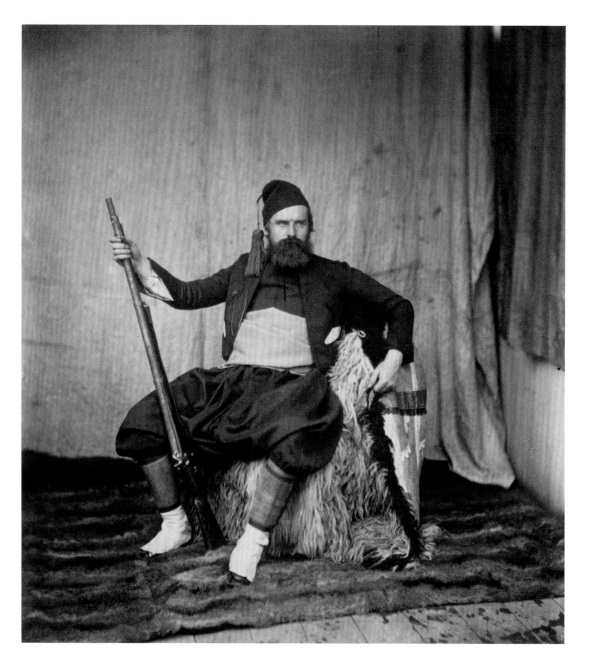

13 **ROGER FENTON**
Self-Portrait in Zouave Uniform, 1855

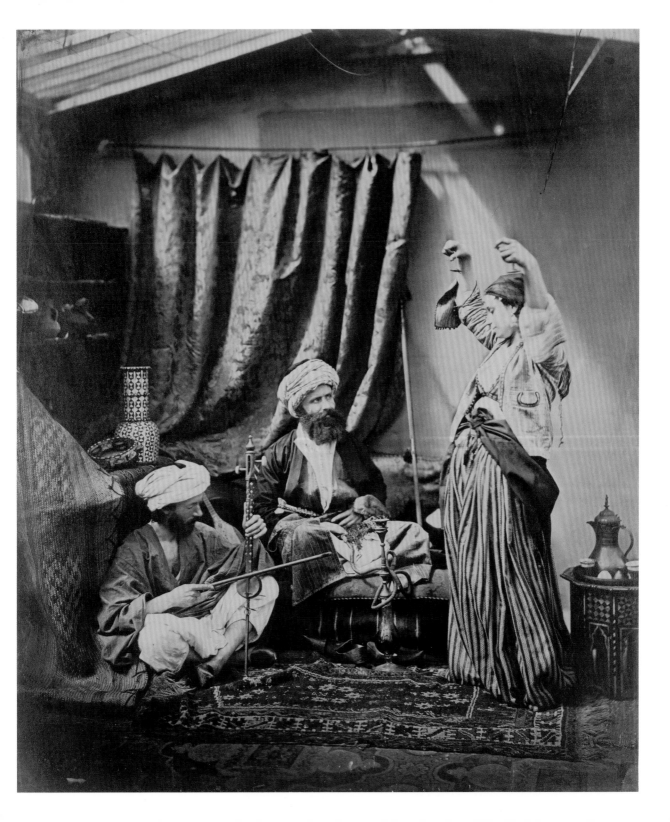

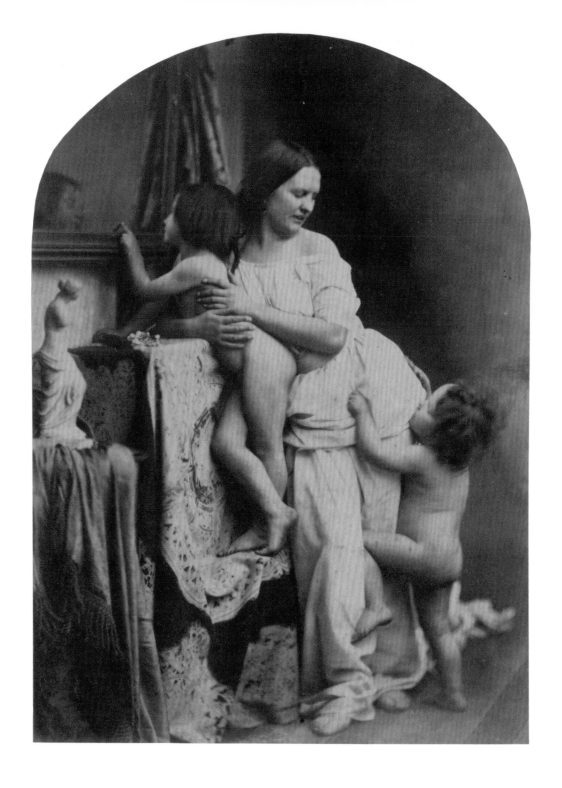

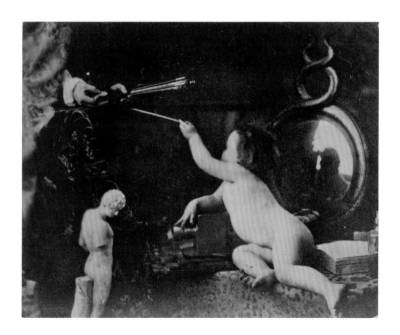

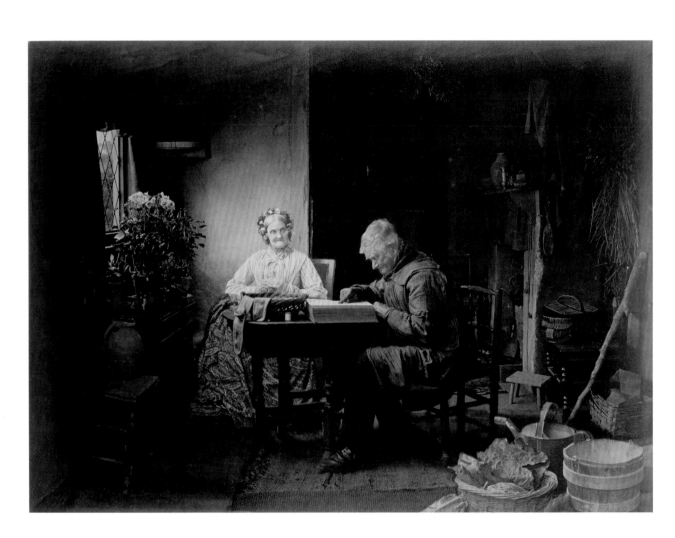

17 **HENRY PEACH ROBINSON**
When the Day's Work Is Done, 1877

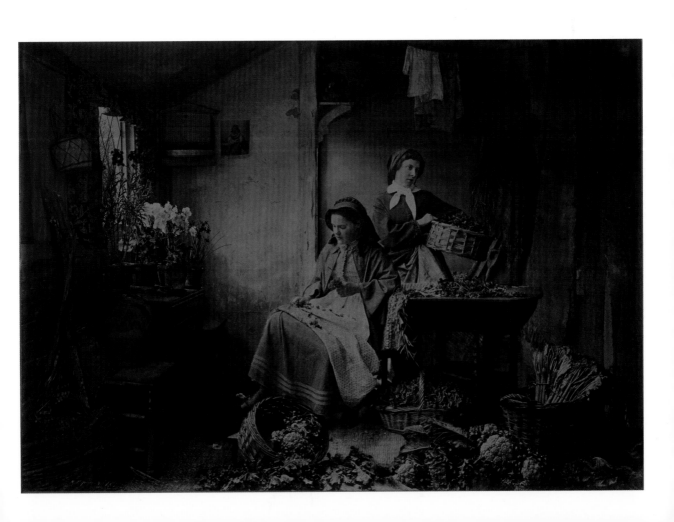

Julia Margaret Cameron was noted for her portraits of influential public figures in her social circle, but many of her photographs were illustrations that drew on literature and religion. As evolutionary science and increasing secularism transformed the way Victorians understood the world, Cameron remained a devout Christian. Her artistic contemporaries, the Pre-Raphaelite painters, who modeled their work on medieval religious and mythological art, inspired Cameron to make tableaux of angels, goddesses, and Madonnas. Her models were her domestic staff and the children of her household, readily available subjects who could be easily cajoled into participation.

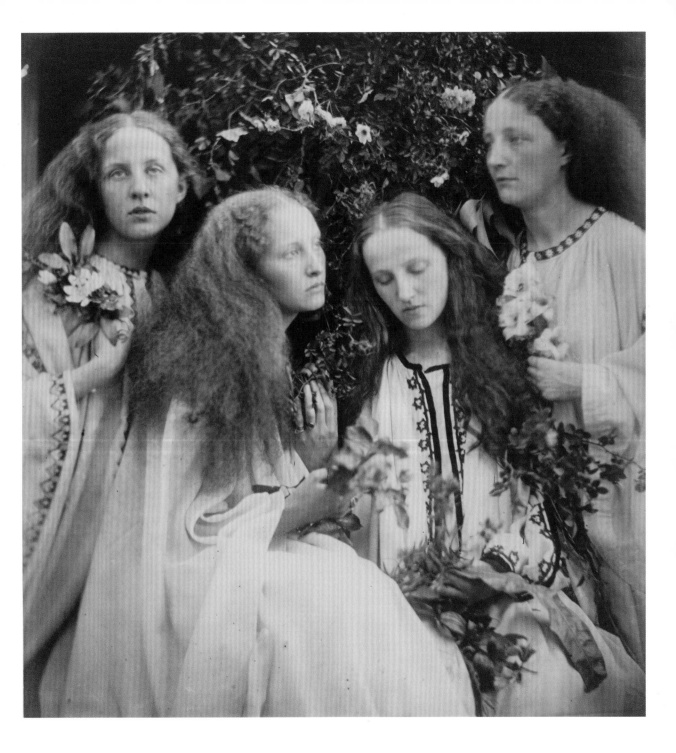

19 JULIA MARGARET CAMERON
The Rosebud Garden of Girls, June 1868

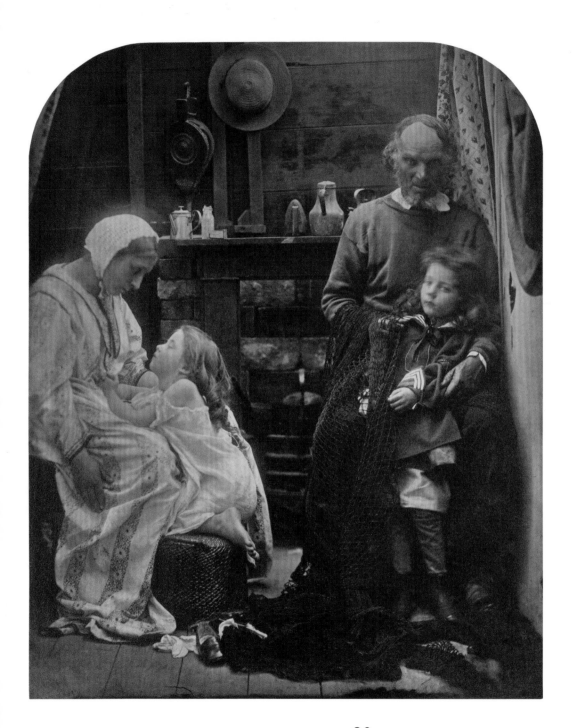

20 JULIA MARGARET CAMERON
Pray God Bring Father Safely Home, negative, 1874; print, 1910

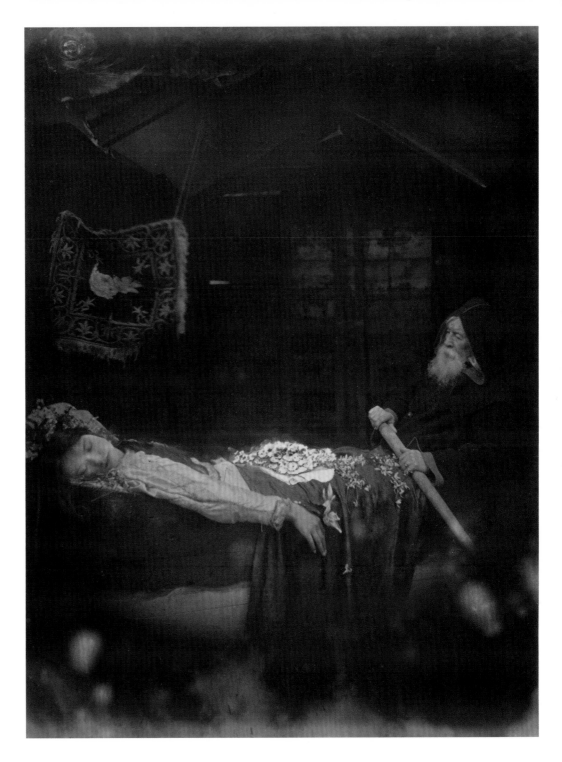

21 JULIA MARGARET CAMERON
Elaine, 1875

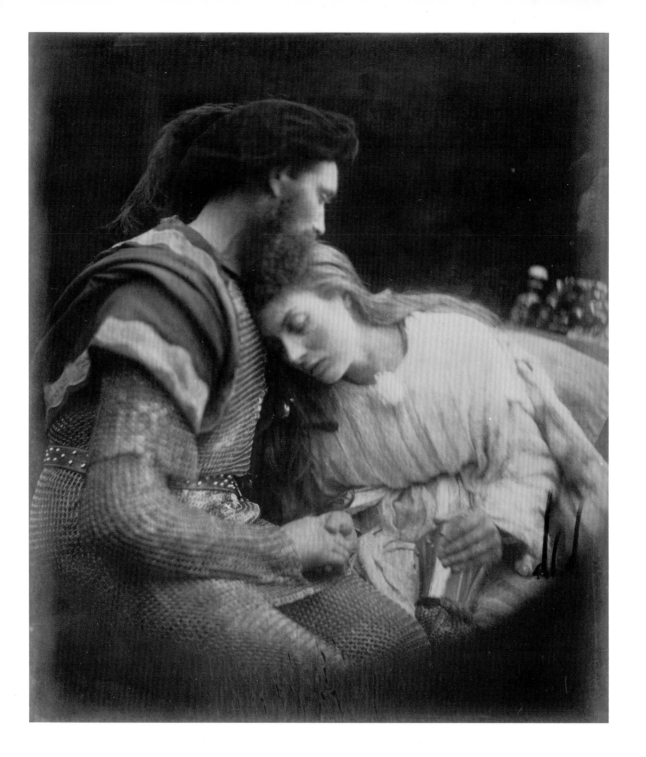

22 **JULIA MARGARET CAMERON**
The Parting of Sir Lancelot and Queen Guinevere, 1874

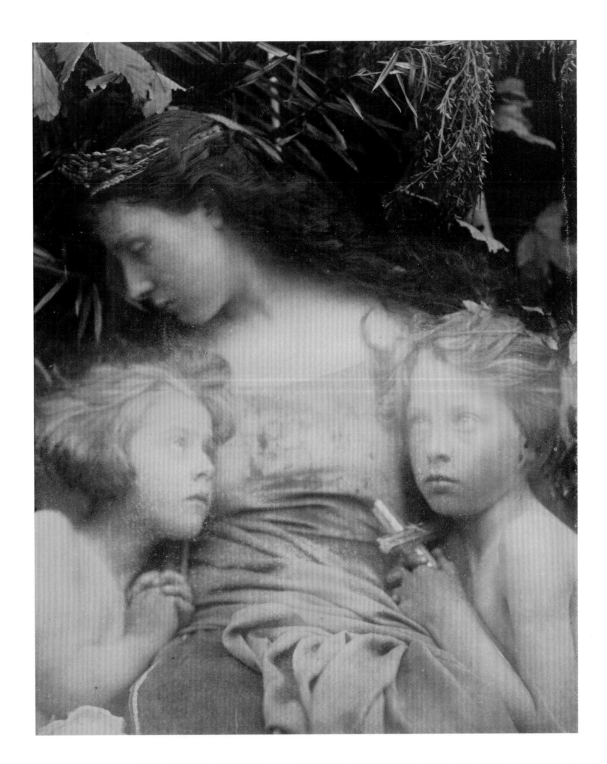

24 LEWIS CARROLL
Achilles in His Tent, June 26, 1875

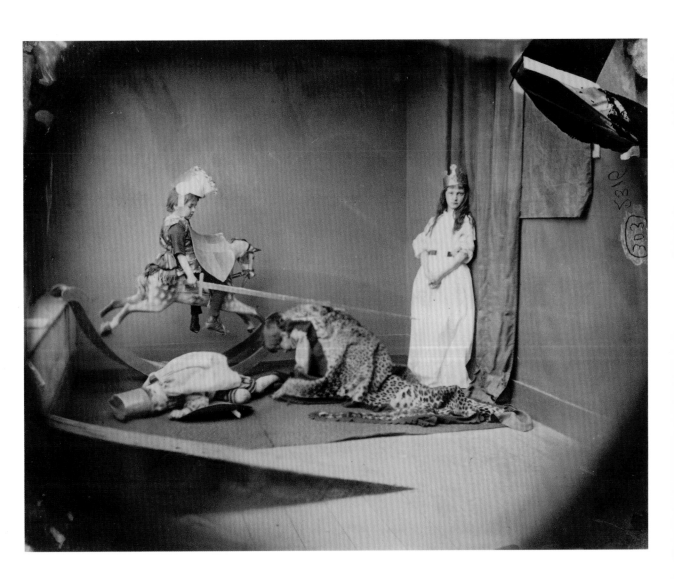

25 **LEWIS CARROLL**
Saint George and the Dragon, June 26, 1875

GERTRUDE KÄSEBIER
The Manger (Ideal Motherhood), 1899

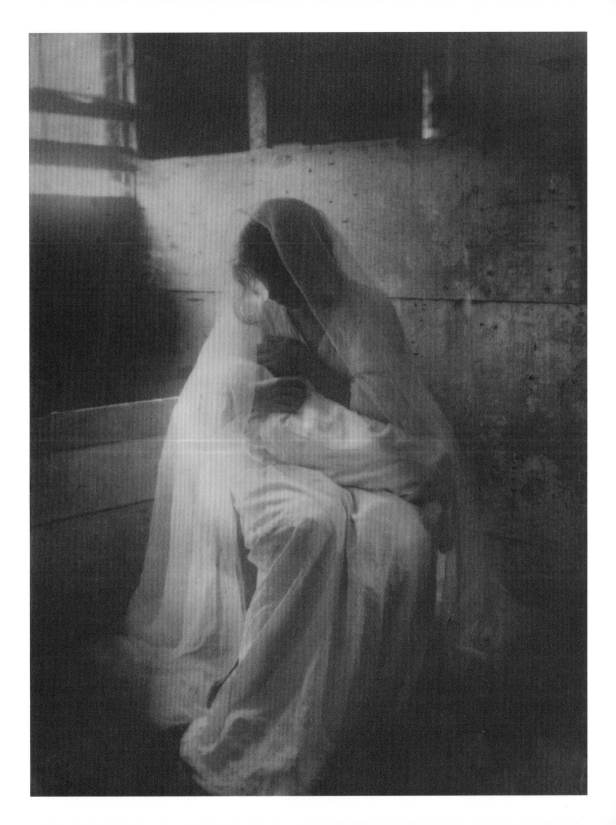

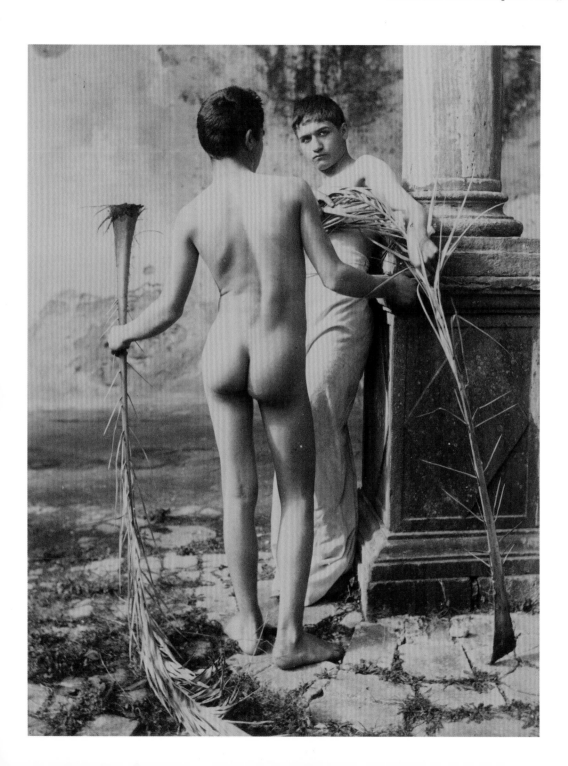

28 BARON WILHELM VON GLOEDEN
Untitled (Sicilian Boy and Girl before Floral Textile), ca. 1900

29 **THOMAS EAKINS**
Untitled (Unidentified Models in the Cast Room
of the Pennsylvania Academy), ca. 1883

30 **THOMAS EAKINS**
Untitled (Unidentified Models with Eakins's Sculpture *Arcadia*),
ca. 1883

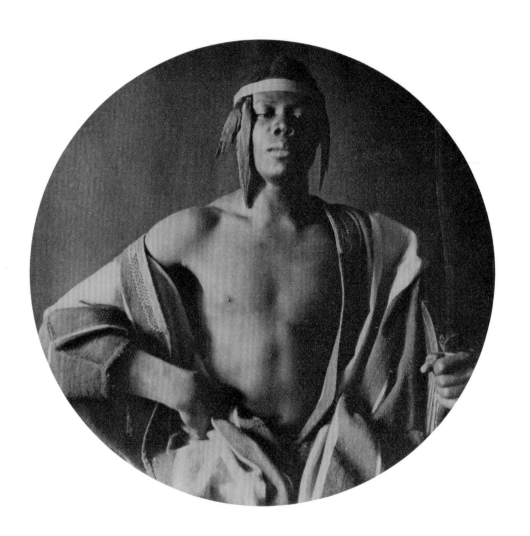

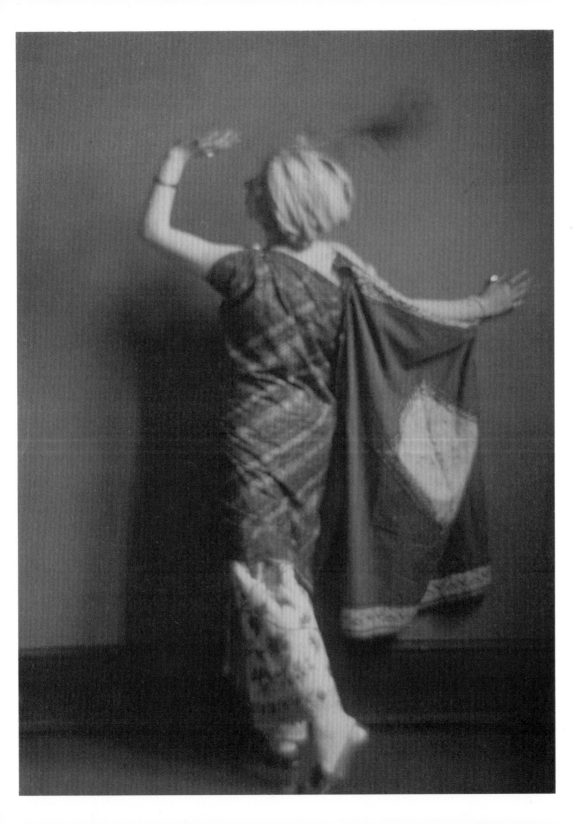

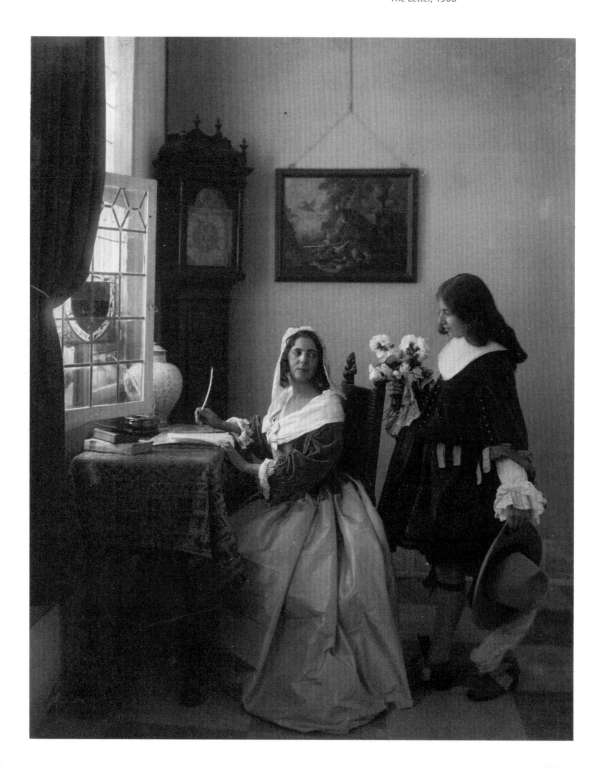

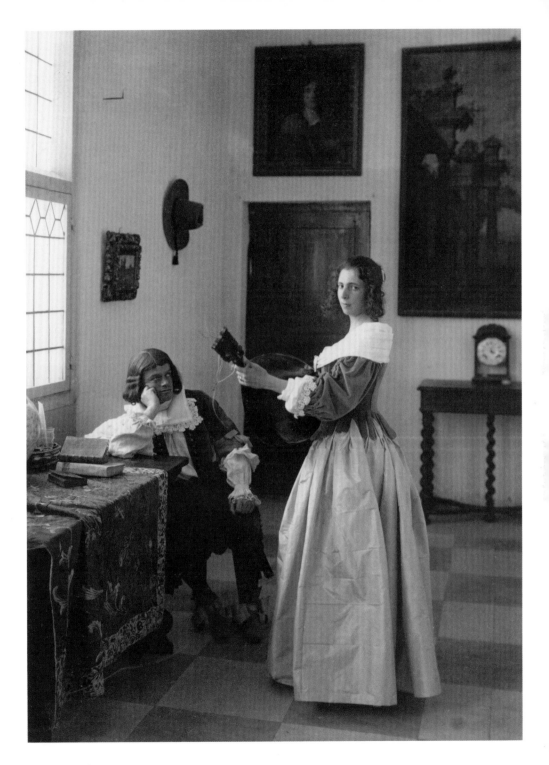

34　　GUIDO REY
Dutch Interior, ca. 1895

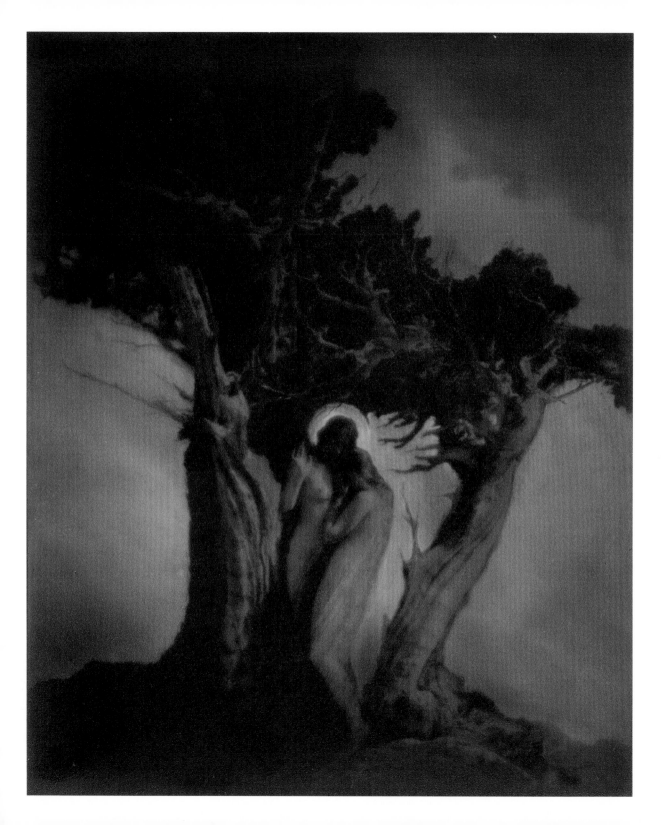

36 **WILLIAM MORTENSEN**
The Bad Thief, 1926

ATTRIBUTED TO ROI PARTRIDGE
Saint Anne of the Crooked Halo, ca. 1920s

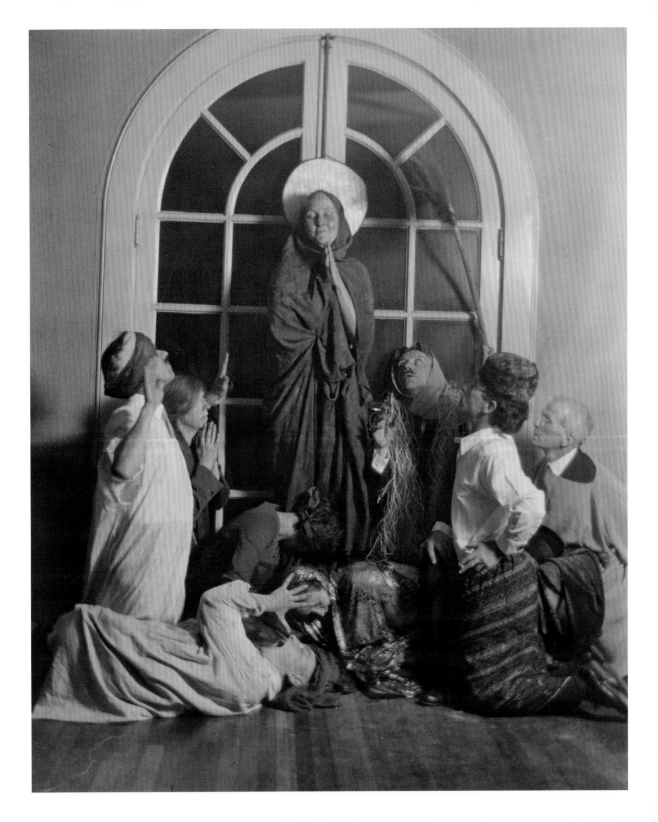

38 **ALFRED STIEGLITZ**
Georgia O'Keeffe, 1918

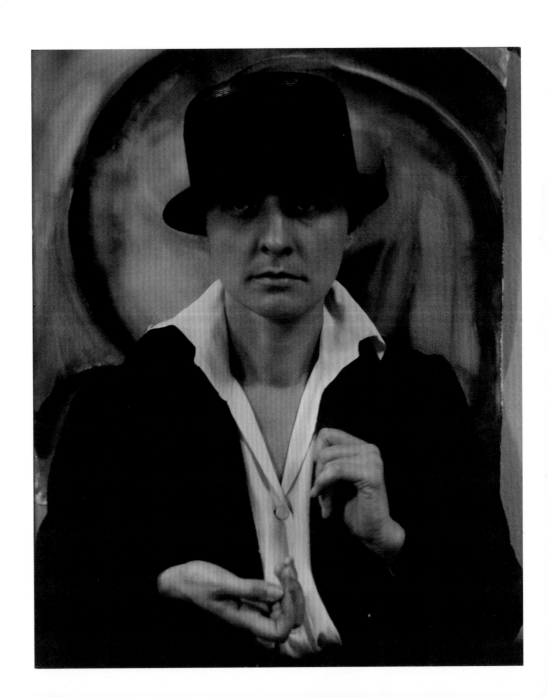

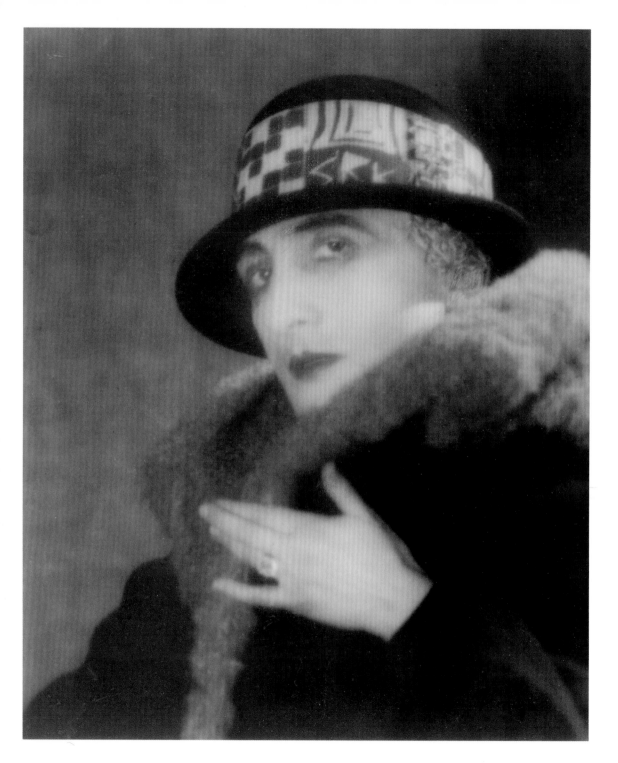

40 **MAN RAY**
Rrose Sélavy (Marcel Duchamp), 1923

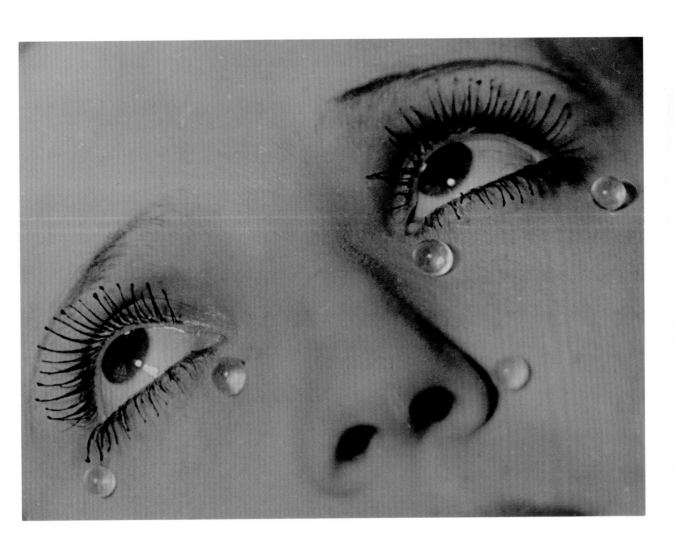

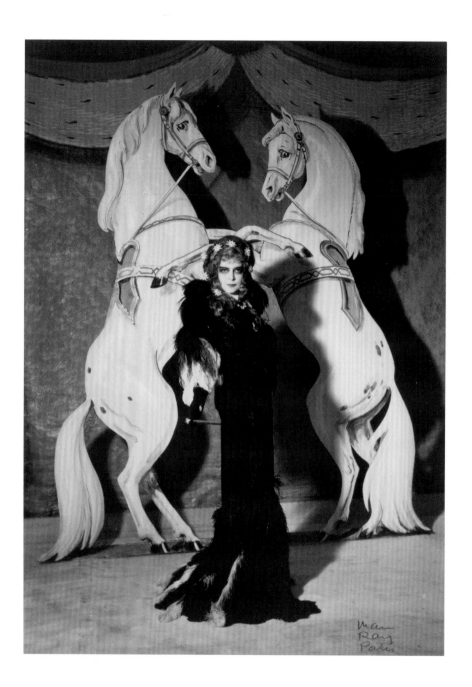

42　**MAN RAY**
The Marquise Casati with Horses, 1935

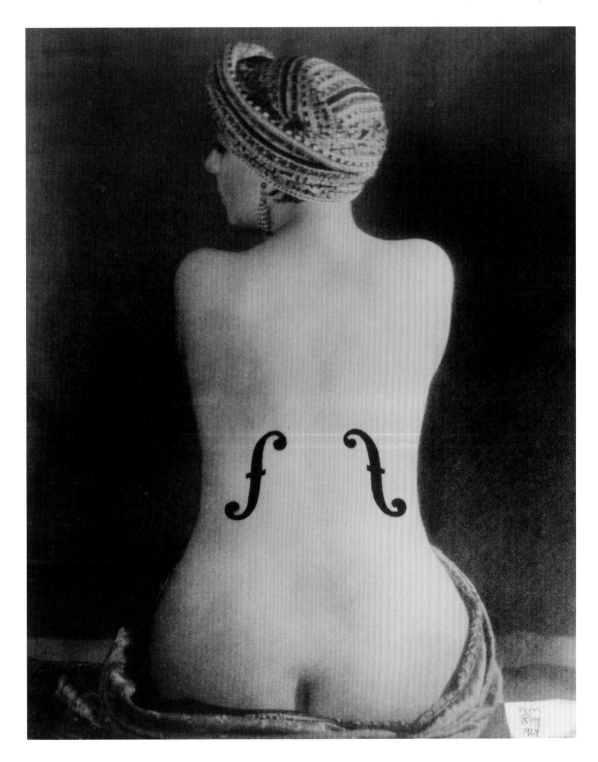

43 **MAN RAY**
Le violon d'Ingres (Ingres's Violin), 1924

Hans Bellmer staged a series of psychosexual tableaux featuring a nearly life-size female doll of his creation. The doll's interchangeable parts allowed Bellmer to assemble her into a variety of contorted poses, so that she appeared as a passive victim at certain times and as a powerful seductress at others. Ten of the photographs appeared in Bellmer's book *La poupée* (1936), including this ghostly self-portrait. The small book was designed so it could be concealed inside a coat pocket for private viewing. Secrecy was crucial, as Bellmer would have been branded a degenerate by Hitler's fascist regime. Bellmer found an audience for his work outside of Germany among the French Surrealists, who reproduced his photographs in their journal *Minotaure*.

44 **HANS BELLMER**
Autoportrait avec la poupée (Self-Portrait with the Doll),
1934–36

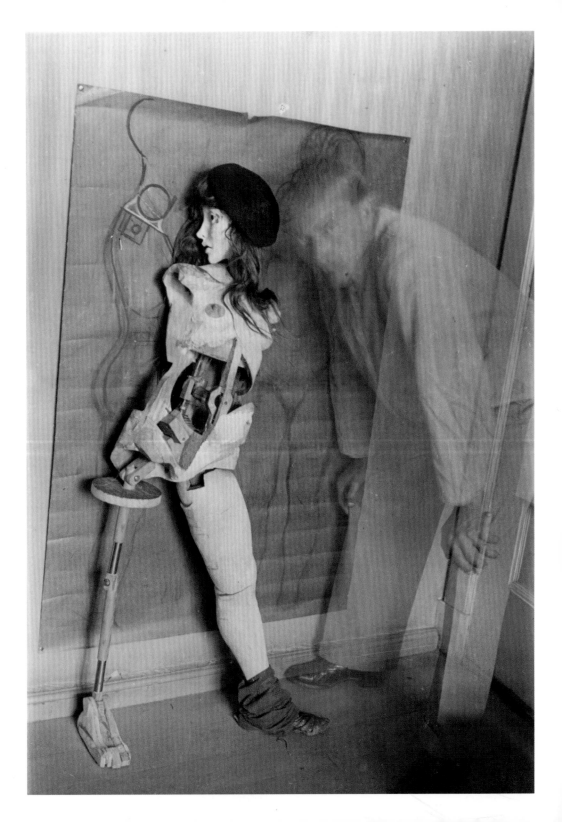

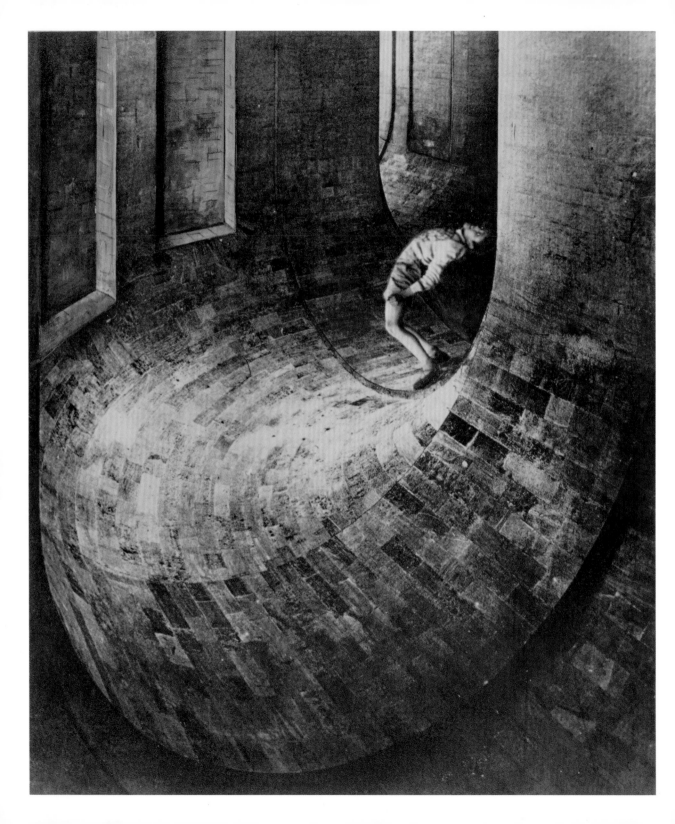

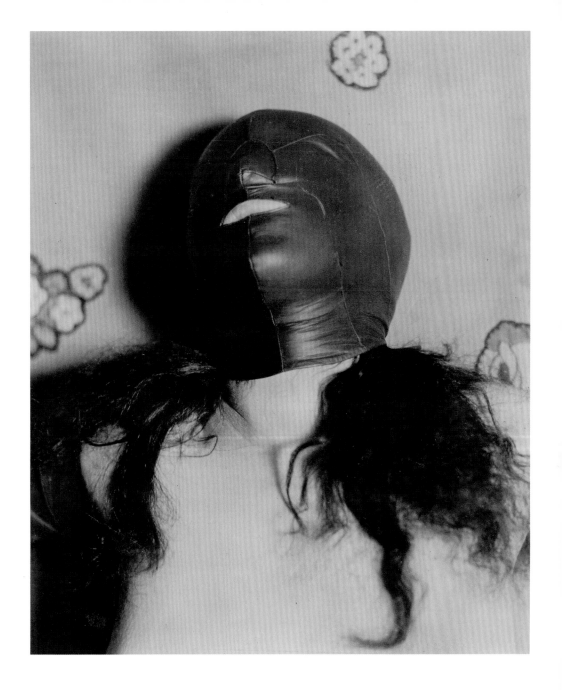

45 **DORA MAAR**
Le simulateur (The Pretender), 1936

46 **JACQUES-ANDRÉ BOIFFARD**
Untitled, 1930

By the mid-1930s, Paul Outerbridge had mastered early color photography and established himself as a pioneer of modernist aesthetics in the world of advertising. Outerbridge's skill with the laborious tri-color carbro process was nowhere more evident than in his ability to render skin with great nuance. To the traditional subject of the nude, Outerbridge brought not only a new medium but also a new aesthetic sensibility. In *Woman with Claws*, he photographed a female model wearing a face mask, her steel-tipped gardening gloves clawing her torso. Outerbridge later decided to alter the composition by cropping the image with a mat, so that only the woman's fragmented torso appeared. Among his most experimental nudes, this picture combines the realism and immediacy of color photography with the fetishistic fantasies of Surrealism. The nature of the photograph prevented its exhibition or publication during Outerbridge's lifetime.

PAUL OUTERBRIDGE
Woman with Claws, 1937

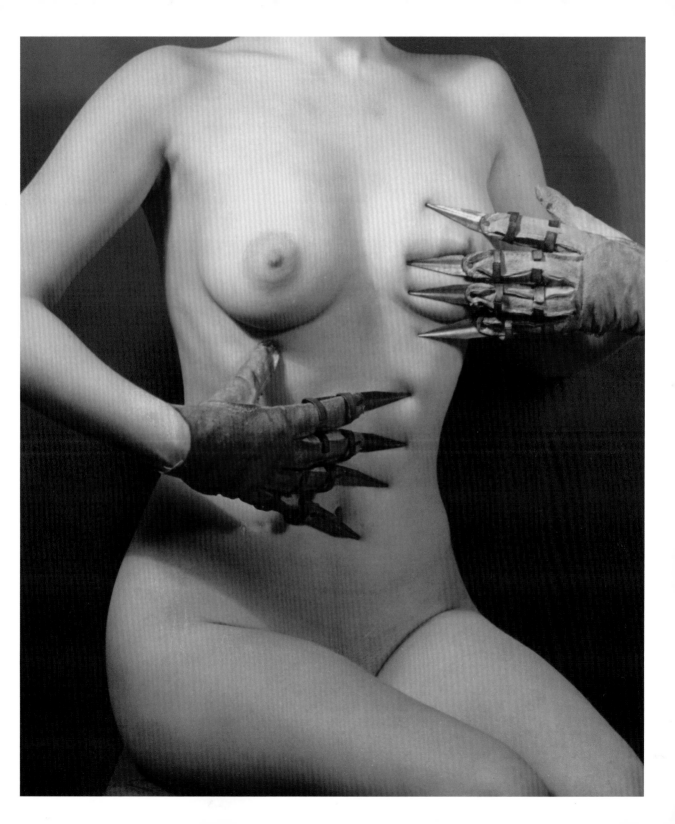

PAUL OUTERBRIDGE
Tableau Vivant, after the Painting *Lot and His Family Fleeing Sodom*, by Peter Paul Rubens, ca. 1951

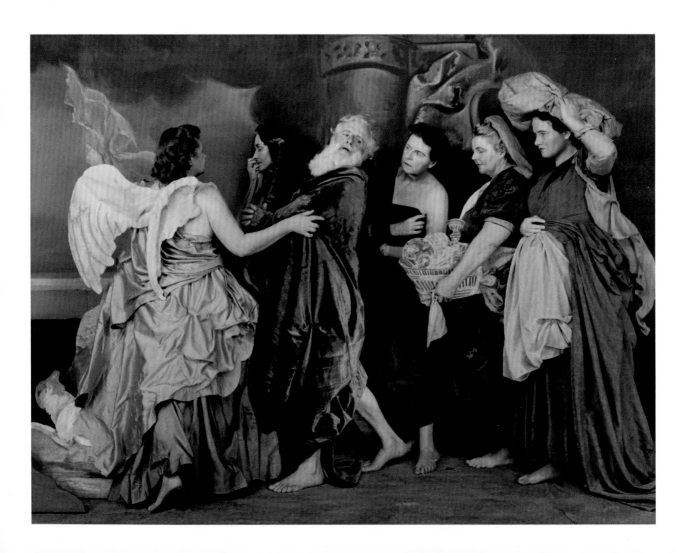

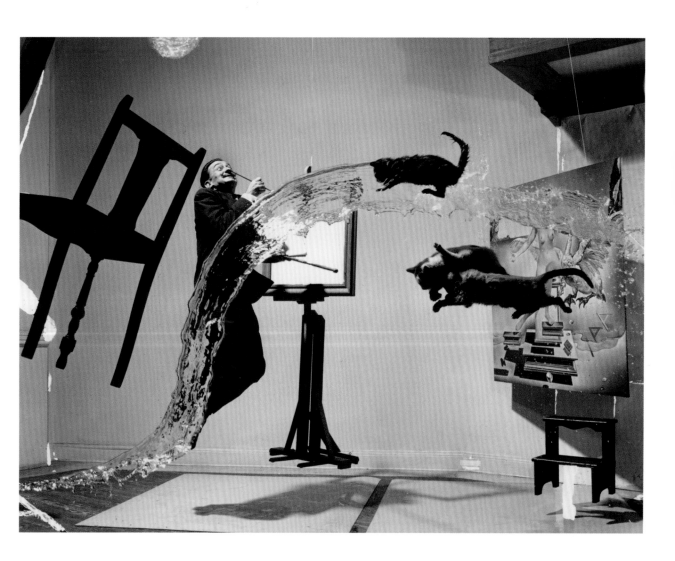

49 **PHILIPPE HALSMAN**
Dali Atomicus, 1948

A member of the Japanese avant-garde, Kansuke Yamamoto experimented with photography and poetry. He was greatly influenced by European Surrealism and interpreted the work of artists such as Man Ray, Salvador Dalí, and René Magritte in his own idiom. The narrative sequence *My Thin-Aired Room* begins with a man sitting next to a table; in subsequent images, his body disappears, leaving behind his jacket, and then his jacket appears to exit through the door. In a fourth and final photograph (not shown), the room appears empty of its furnishings. Evident in this visual poem is Yamamoto's interest, shared by his European counterparts, in playacting and performance, but the work does not delve deeply into the subconscious mind or other transgressive subject matter. Nevertheless, the Japanese Special Higher Police, known as the "thought police," considered Yamamoto's strange imagery subversive and subjected him to severe interrogation and persecution.

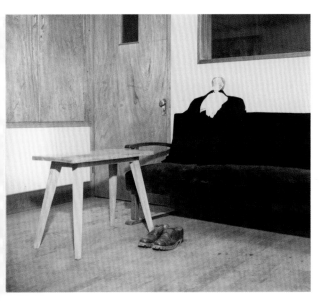 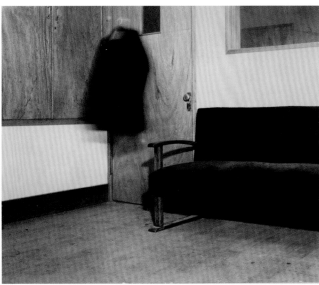

JOEL-PETER WITKIN
Mother and Child (with Retractor, Screaming), 1979

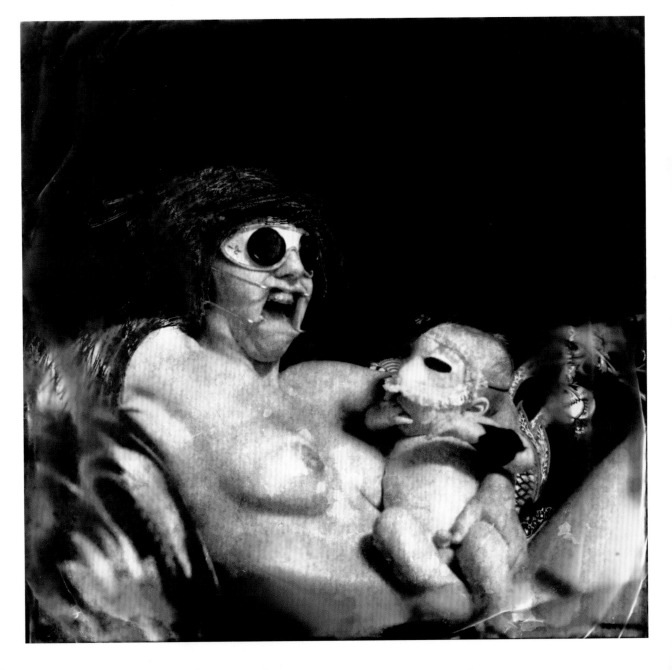

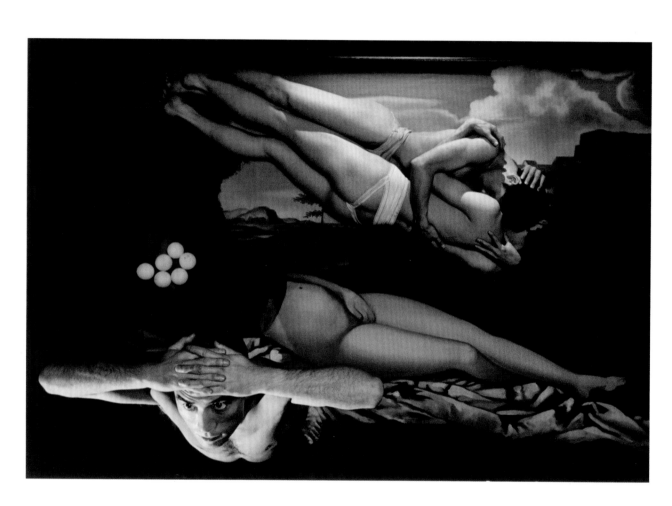

52 **EIKOH HOSOE**
Barakei #16, from the series Ordeal by Roses, 1962

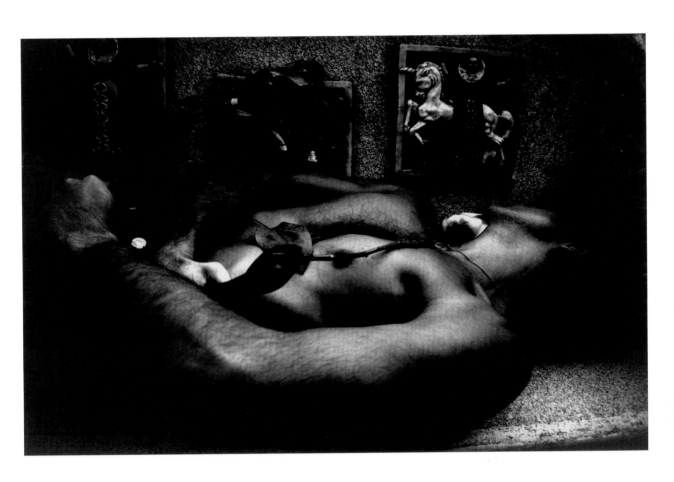

53 **EIKOH HOSOE**
Barakei #39, from the series Ordeal by Roses, 1961

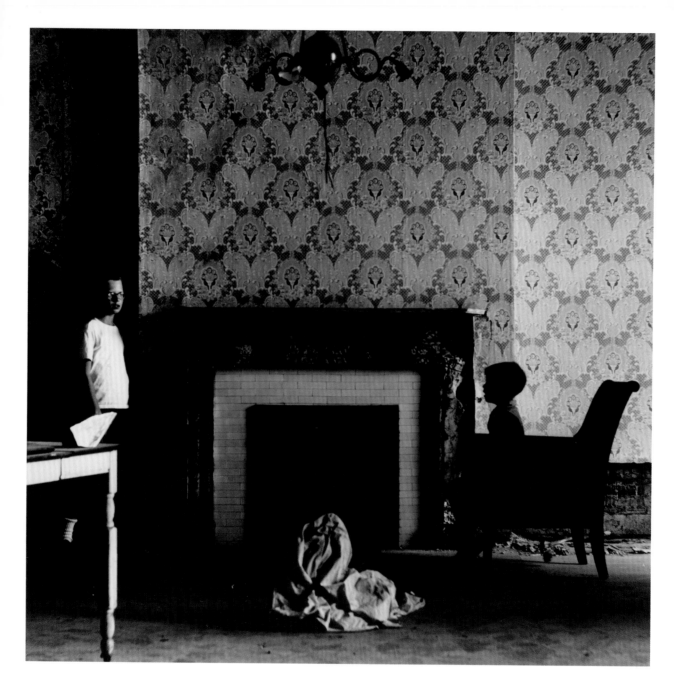

54 RALPH EUGENE MEATYARD
Life of Aspersorium, 1960

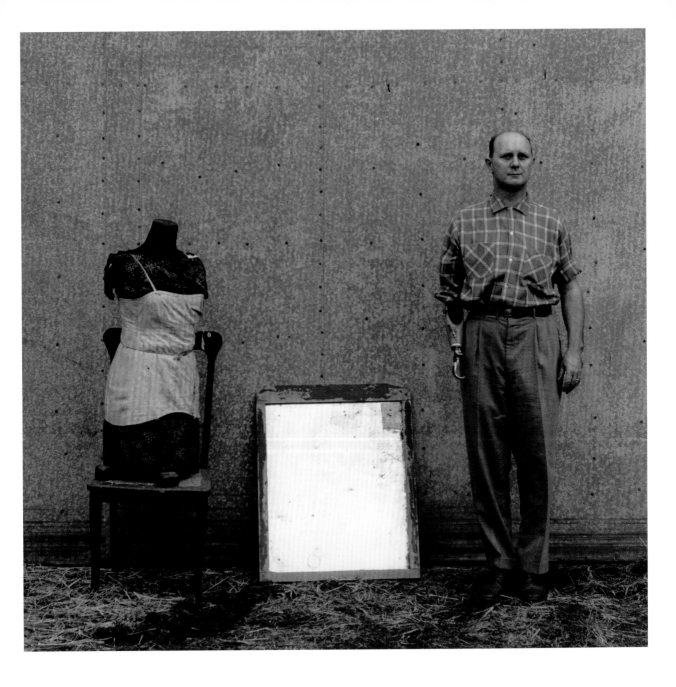

55 RALPH EUGENE MEATYARD
Untitled (Cranston Ritchie), 1964

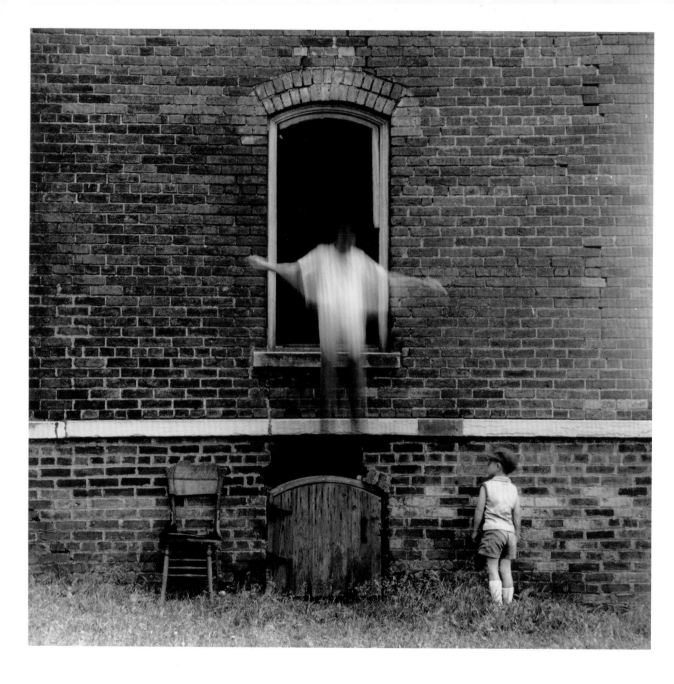

56 **RALPH EUGENE MEATYARD**
Untitled (Michael and Christopher Meatyard), 1966

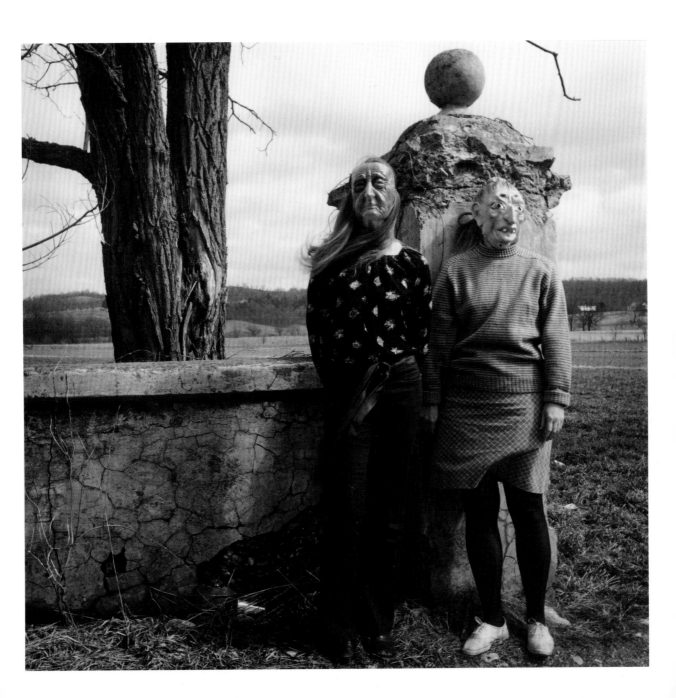

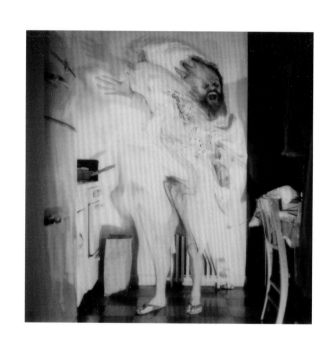

LUCAS SAMARAS
Photo-Transformation, June 13, 1974

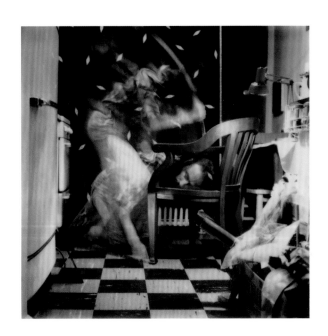

59 **LUCAS SAMARAS**
Photo-Transformation, 1976

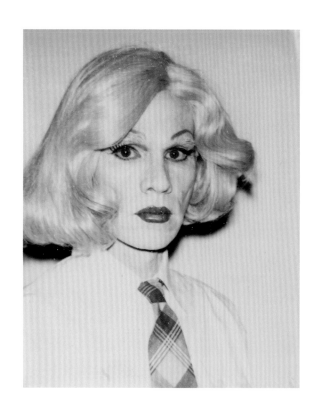

60 **ANDY WARHOL**
Self-Portrait (in Drag), 1981

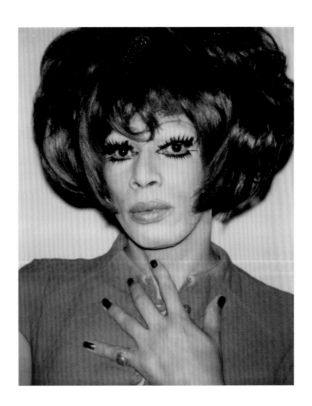

61　ANDY WARHOL
Helen/Harry Morales, from the series Ladies and Gentlemen, 1974

62 **SANDY SKOGLUND**
Revenge of the Goldfish, ©1981

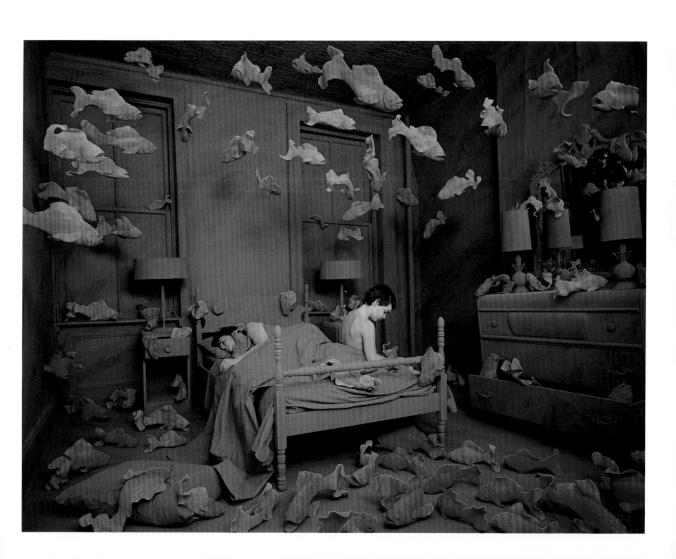

Jo Ann Callis created *Woman with Blue Bow* shortly after seeing the saturated hues of Paul Outerbridge's seductive commercial photographs of fetishistic subjects. Like Outerbridge, Callis uses color and careful staging to expressive ends. She fabricates every detail of her work, creating the sets, making the props, and directing the models. Her enigmatic photographs hint at secret narratives. Figures strain themselves in displays of physical prowess: a man does push-ups between two chairs (plate 64), a woman performs a handstand (plate 65). Interior spaces are familiar, with ordinary furniture and decorative wallpaper, but they evoke a heightened sense of anxiety. Instead of re-creating life's dramatic moments, Callis's photographs conjure the internal emotions that fill domestic spaces.

63 **JO ANN CALLIS**
Woman with Blue Bow, 1977

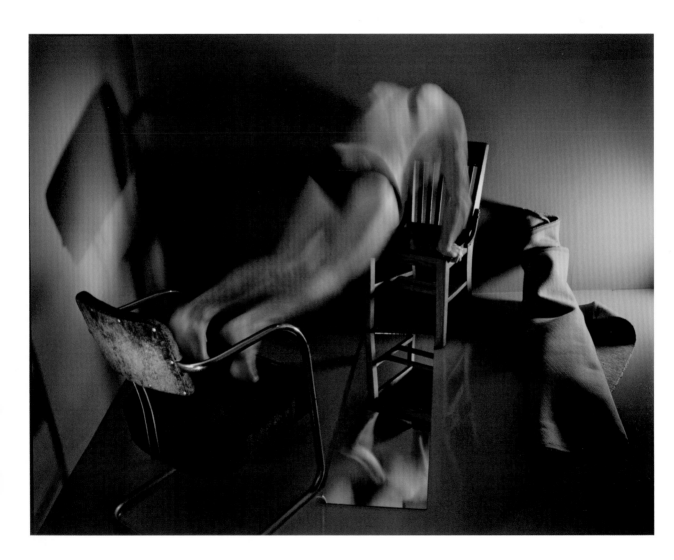

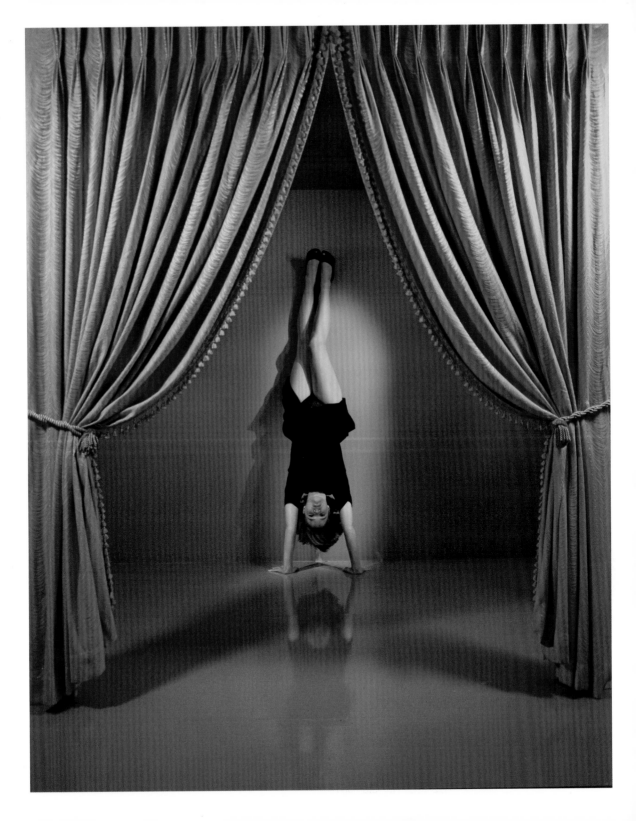

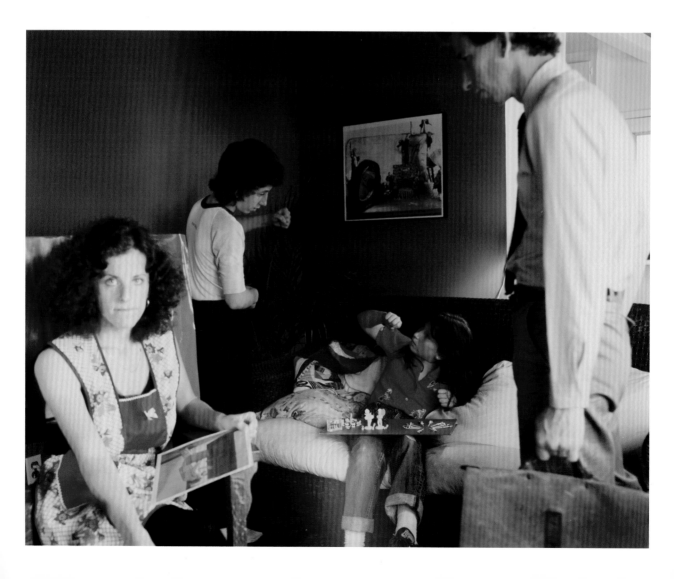

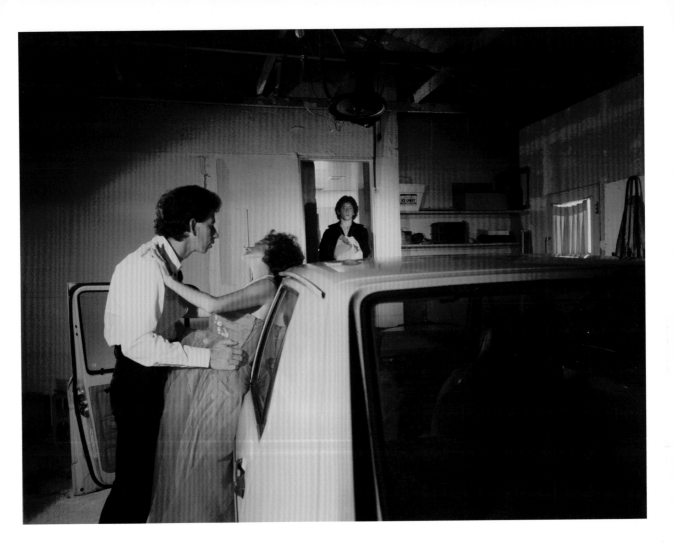

67 **EILEEN COWIN**
Untitled, from the series Family Docudrama, 1980–83

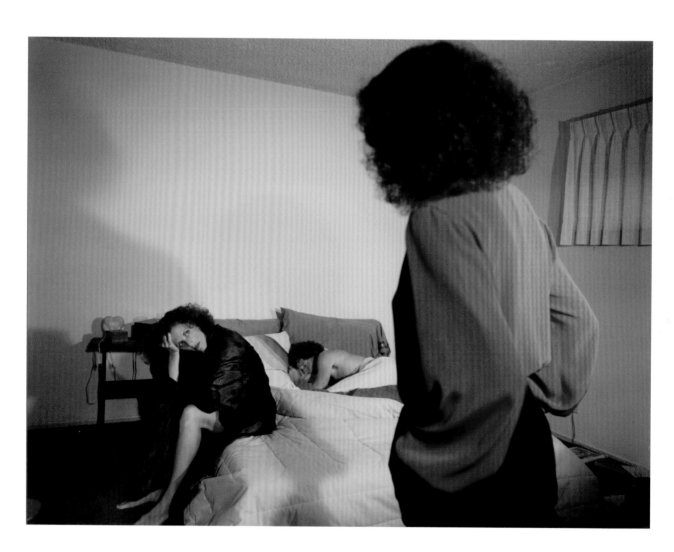

68 EILEEN COWIN
Untitled, from the series Family Docudrama, 1980–83

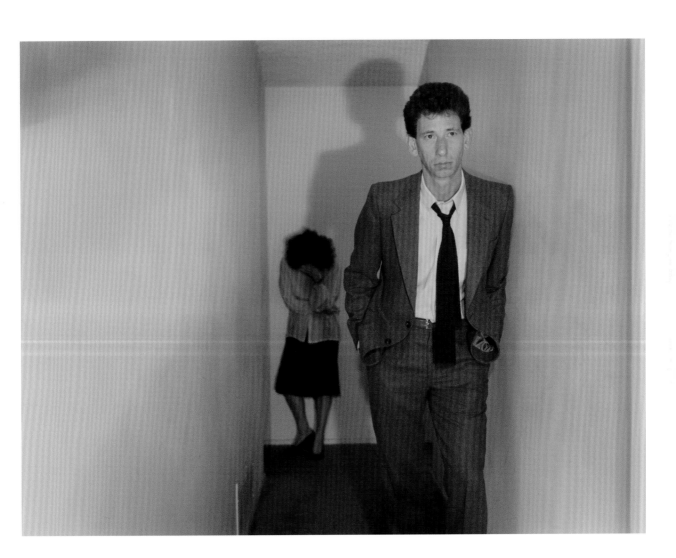

69 **EILEEN COWIN**
Untitled, from the series Family Docudrama, 1980–83

Liu Zheng's work investigates the relationship between contemporary culture and China's long history.

This image is from a series of photographic tableaux inspired by early-twentieth-century Peking Opera stills. The Peking Opera is considered the cornerstone of Chinese high culture, but in Liu Zheng's work it stands for traditional values. Liu Zheng's pictures present a well-known opera and look like actual publicity photographs, which can be found in Chinese antique shops. Much like these vintage stills, Liu Zheng's tableaux were staged in a studio, using costumes, props, and actors. He also intentionally imitated the antique quality of the old pictures by distressing his negatives. In a controversial twist, the female performers in Liu Zheng's photographs appear nude.

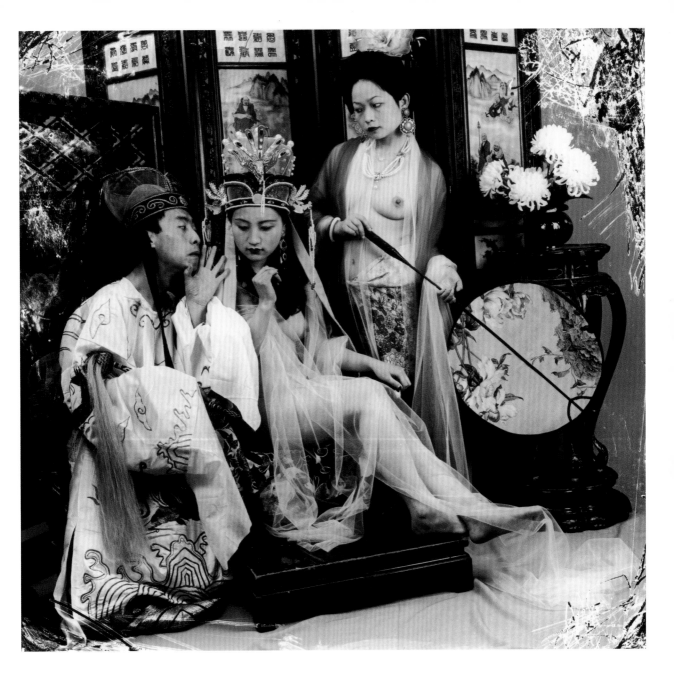

70 **LIU ZHENG**
Peking Opera, Self-Portrait, 1997

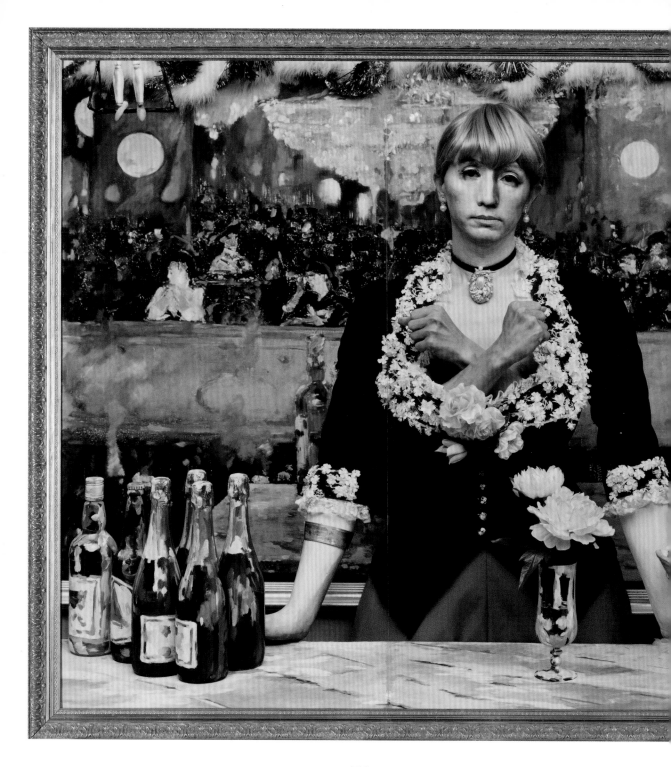

71 **YASUMASA MORIMURA**
Daughter of Art History, Theater A, 1989

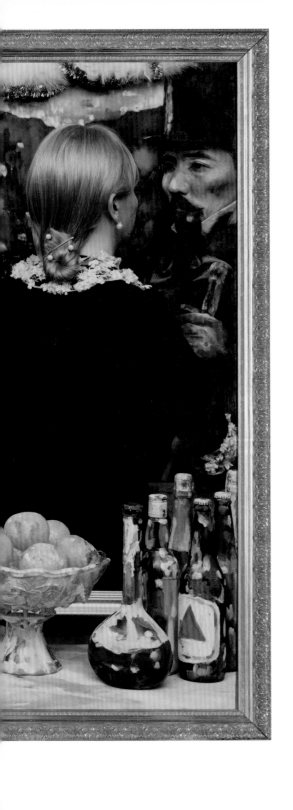

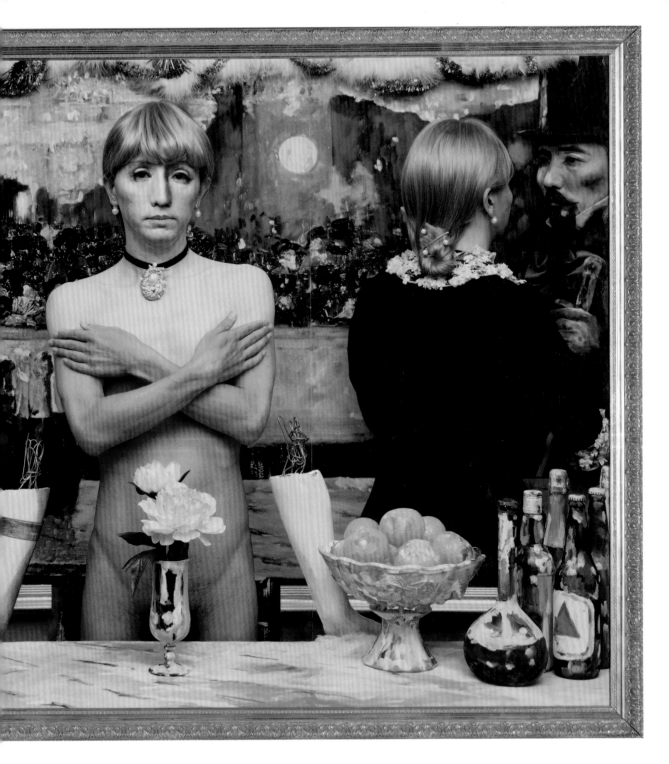

72 **YASUMASA MORIMURA**
Daughter of Art History, Theater B, 1989

In *School Days,* Tomoko Sawada mimics the format of a formal class portrait but casts herself as each of the students, and as the teacher, using digital technology. The photograph questions the reliability of outward appearances and explores stereotypes. Sawada's physical appearance is remarkably malleable. She transforms most radically in her convincing impersonation of the teacher, but it is in the forty students, all wearing the same school uniform, that her investigation of identity is most complex. Sawada made minimal changes to her costume, hair, makeup, expression, and body language to create each student. One stands with her hip cocked; others rest their clasped hands on their laps. A girl with pigtails smiles, while another hides a sullen expression behind bangs. Unique personalities emerge in these subtle differences, but in the end they are all the same person.

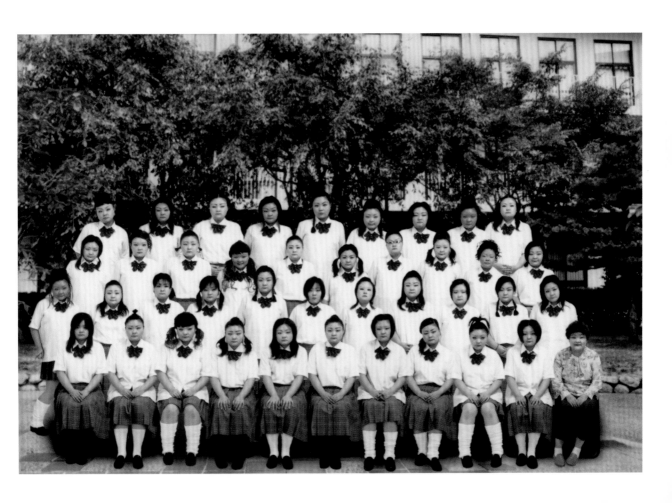

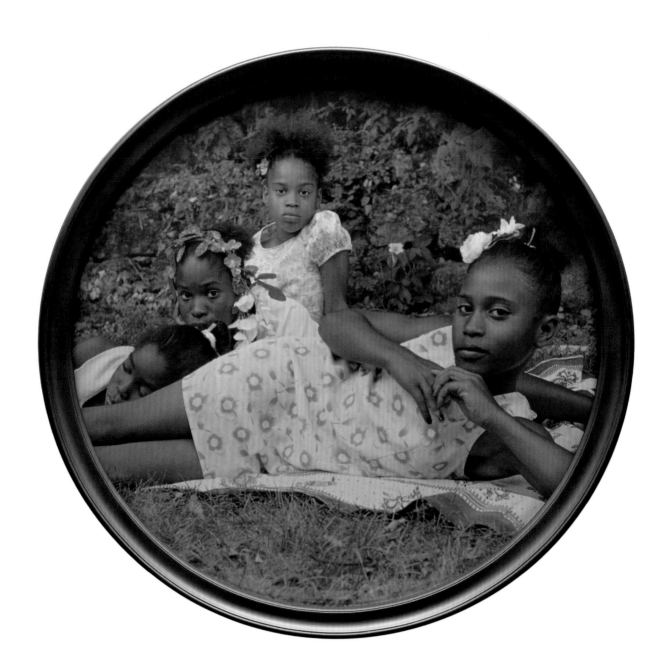

74 **CARRIE MAE WEEMS**
After Manet, from the series May Days Long Forgotten, 2003

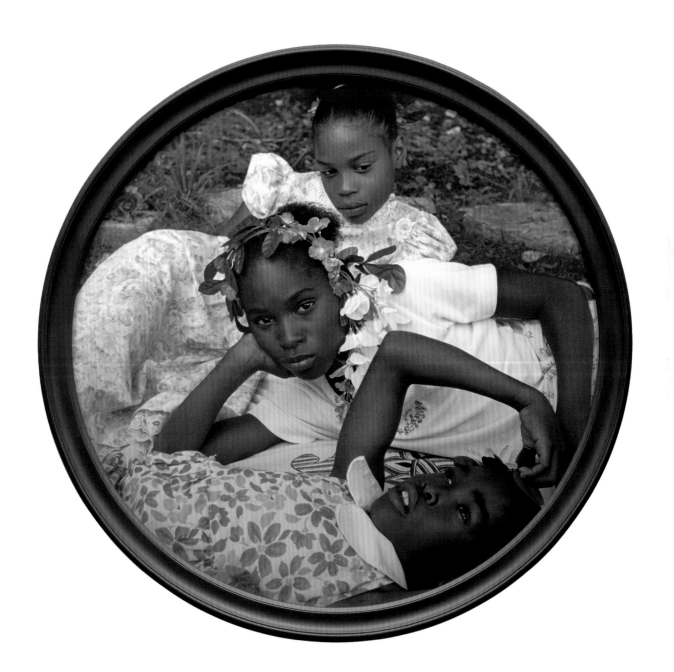

75 CARRIE MAE WEEMS
May Flowers, from the series May Days Long Forgotten, 2003

Loretta Lux's otherworldly photographs of children recall the work of Lewis Carroll. Her subjects are the sons and daughters of friends, whom she photographs in carefully composed scenes. To create her "imaginary portraits," as she describes them, Lux poses the children in vintage clothing, sometimes with props, against white backdrops. She then digitally combines the images with her own paintings of landscapes or empty rooms and manipulates details like the physical proportions of the children or the transparency of their skin. Lux trained as a classical painter, and the influence of masters such as Diego Velázquez and Francisco de Goya is evident in her work. At the same time, Lux's disturbingly flawless subjects exude a distinctly contemporary deadpan manner.

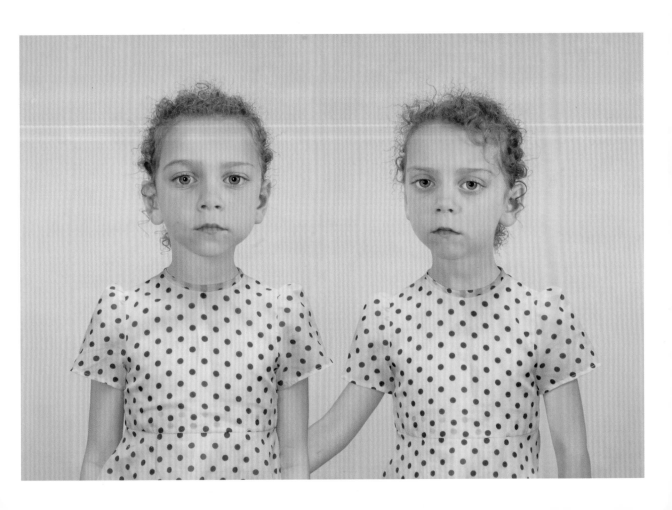

Plate List

All photographs are from the collection of the J. Paul Getty Museum, Los Angeles.

1

JOHN PLUMBE JR.
American, born Wales, 1809–1857
*Portrait of a Man Reading
a Newspaper*, ca. 1842
Daguerreotype
8.9 × 7 cm (3½ × 2¾ in.)
84.XT.1565.22

2

UNKNOWN FRENCH PHOTOGRAPHER
*A Sister of Charity Serving a
Patient at the Hospice de Beaune*,
ca. 1848
Daguerreotype, hand-colored
12.4 × 9.1 cm (4⅞ × 3⁹⁄₁₆ in.)
84.XT.404.6

3

**UNKNOWN AMERICAN
PHOTOGRAPHER**
Two Metalworkers, 1855
Daguerreotype
6.8 × 5.7 cm (2¹¹⁄₁₆ × 2¼ in.)
84.XT.1572.5

4

WARREN T. THOMPSON
American, act. 1840–1870
Self-Portrait as a Hunter, ca. 1855
Stereo daguerreotype,
hand-colored
6.7 × 5.8 cm (2⅝ × 2⁵⁄₁₆ in.)
84.XT.838.1

5

UNKNOWN BRITISH PHOTOGRAPHER
Man Posed with Fishing Gear,
ca. 1860
Ambrotype
26 × 23.4 cm (10¼ × 9¼ in.)
84.XT.454

6

WILLIAM H. MUMLER
American, 1832–1884
*Mrs. S. A. Floyd with Native
American Spirit*, 1862–75
Albumen silver print
10 × 5.7 cm (3¹⁵⁄₁₆ × 2¼ in.)
84.XD.760.1.31

7

WILLIAM H. MUMLER
American, 1832–1884
*Harry Gordon with the Spirit
of a Man Handing Him a Cross*,
1862–75
Albumen silver print
10 × 5.7 cm (3¹⁵⁄₁₆ × 2¼ in.)
84.XD.760.1.39

8

WILLIAM H. MUMLER
American, 1832–1884
*Fanny Conant with Spirit Arms
and Hands Showering Her with
Flowers*, 1870–75
Albumen silver print
10 × 5.7 cm (3¹⁵⁄₁₆ × 2¼ in.)
84.XD.760.1.17

9

WILLIAM H. MUMLER
American, 1832–1884
*Bronson Murray in a Trance with
the Spirit of Ella Bonner*, 1872
Albumen silver print
10 × 5.7 cm (3¹⁵⁄₁₆ × 2¼ in.)
84.XD.760.1.11

10

DAVID OCTAVIUS HILL
Scottish, 1802–1870
ROBERT ADAMSON
Scottish, 1821–1848
*Greyfriars Churchyard, the
Dennistoun Monument with D. O.
Hill and His Nieces*, 1843–47
Salted paper print from a
calotype negative
19.8 × 15.1 cm (7¹³⁄₁₆ × 5¹⁵⁄₁₆ in.)
84.XM.263.5

11

DAVID OCTAVIUS HILL
Scottish, 1802–1870
ROBERT ADAMSON
Scottish, 1821–1848
*Mrs. Elizabeth Cockburn Cleghorn
and John Henning as Miss
Wardour and Edie Ochiltree from
Sir Walter Scott's* The Antiquary,
1846–47
Salted paper print from a
calotype negative
20.6 × 15.7 cm (8⅛ × 6³⁄₁₆ in.)
88.XM.57.21

12

ROGER FENTON
English, 1819–1869
Contemplative Odalisque, 1858
Albumen silver print
36.2 × 43.8 cm (14¼ × 17¼ in.)
Gift of Professors Joseph and
Elaine Monsen
92.XM.53

13

ROGER FENTON
English, 1819–1869
Self-Portrait in Zouave Uniform,
1855
Albumen silver print
17.3 × 15.2 cm (6¹³⁄₁₆ × 6 in.)
84.XM.1028.17

14

ROGER FENTON
English, 1819–1869
Pasha and Bayadère, 1858
Albumen silver print
45 × 36.2 cm (17¹¹⁄₁₆ × 14¼ in.)
84.XP.219.32

15

OSCAR GUSTAVE REJLANDER
English, born Sweden, 1813–1875
*The Madonna and Child with
Saint John the Baptist*, ca. 1860
Albumen silver print
17.8 × 12.4 cm (7 × 4⅞ in.)
84.XM.845.1

16

OSCAR GUSTAVE REJLANDER
English, born Sweden, 1813–1875
*The Infant Photography Giving
the Painter an Additional Brush*,
ca. 1856
Albumen silver print
6 × 7.1 cm (2⅜ × 2¹³⁄₁₆ in.)
84.XP.458.34

17

HENRY PEACH ROBINSON
English, 1830–1901
When the Day's Work Is Done,
1877
Albumen silver print
56 × 74.5 cm (22¹⁄₁₆ × 29⁵⁄₁₆ in.)
84.XM.898

18

HENRY PEACH ROBINSON
English, 1830–1901
*Preparing Spring Flowers
for Market*, 1873
Albumen silver print,
hand-colored
55.9 × 76.2 cm (22 × 30 in.)
86.XM.603

19

JULIA MARGARET CAMERON
English, born India, 1815–1879
The Rosebud Garden of Girls,
June 1868
Albumen silver print
29.4 × 26.7 cm (11⁹⁄₁₆ × 10½ in.)
84.XM.443.66

20

JULIA MARGARET CAMERON
English, born India, 1815–1879
*Pray God Bring Father Safely
Home*, negative 1874, print 1910
Carbon print
37.8 × 29.5 cm (14⅞ × 11⅝ in.)
84.XM.349.14

21

JULIA MARGARET CAMERON
English, born India, 1815–1879
Elaine, 1875
Albumen silver print
35.9 × 26 cm (14⅛ × 10¼ in.)
84.XP.459.4

22

JULIA MARGARET CAMERON
English, born India, 1815–1879
*The Parting of Sir Lancelot
and Queen Guinevere*, 1874
Albumen silver print
34.3 × 28.9 cm (13½ × 11⅜ in.)
84.XO.732.2.10

23

JULIA MARGARET CAMERON
English, born India, 1815–1879
Une sainte famille (A Holy Family),
August 1872
Albumen silver print
33.5 × 26.7 cm (13³⁄₁₆ × 10½ in.)
84.XM.443.73

24

LEWIS CARROLL
English, 1832–1898
Achilles in His Tent, June 26, 1875
Albumen silver print
13.7 × 10.8 cm (5⅜ × 4¼ in.)
84.XM.803.5

25

LEWIS CARROLL
English, 1832–1898
Saint George and the Dragon,
June 26, 1875
Albumen silver print
12.2 × 16.2 cm (4¹³⁄₁₆ × 6⅜ in.)
84.XP.458.15

26

GERTRUDE KÄSEBIER
American, 1852–1934
The Manger (Ideal Motherhood),
1899
Platinum print
32.5 × 23.7 cm (12¹³⁄₁₆ × 9⁵⁄₁₆ in.)
84.XM.160.1

27

BARON WILHELM VON GLOEDEN
German, 1856–1931
*Untitled (Two Youths Holding Palm
Fronds)*, ca. 1885–1905
Albumen silver print
23.3 × 17.5 cm (9³⁄₁₆ × 6⅞ in.)
84.XM.631.5

28

BARON WILHELM VON GLOEDEN
German, 1856–1931
*Untitled (Sicilian Boy and Girl
before Floral Textile)*, ca. 1900
Albumen silver print
21.6 × 16.5 cm (8½ × 6½ in.)
84.XP.460.9

29

THOMAS EAKINS
American, 1844–1916
*Untitled (Unidentified Models in
the Cast Room of the Pennsylvania
Academy)*, ca. 1883
Albumen silver print
11.9 × 9.5 cm (4¹¹⁄₁₆ × 3¾ in.)
84.XM.254.3

30

THOMAS EAKINS
American, 1844–1916
Untitled (Unidentified Models with Eakins's Sculpture Arcadia*)*,
ca. 1883
Platinum print
8.7 × 7.3 cm (3⁷⁄₁₆ × 2⁷⁄₈ in.)
84.XM.155.2

31

FRED HOLLAND DAY
American, 1864–1933
An Ethiopian Chief,
negative 1897; print ca. 1905
Gum bichromate print
11.9 × 11.7 cm (4¹¹⁄₁₆ × 4⁵⁄₈ in.)
84.XM.170.2

32

IMOGEN CUNNINGHAM
American, 1883–1976
Self-Portrait in Javanese Costume,
1912
Platinum print
16 × 11.3 cm (6⁵⁄₁₆ × 4⁷⁄₁₆ in.)
87.XM.74.6

33

GUIDO REY
Italian, 1861–1935
The Letter, 1908
Platinum print
22.2 × 14 cm (8¾ × 5½ in.)
85.XP.314.7

34

GUIDO REY
Italian, 1861–1935
Dutch Interior, ca. 1895
Platinum print
21.9 × 15.6 cm (8⅝ × 6⅛ in.)
94.XM.9.3

35

ANNE W. BRIGMAN
American, 1869–1950
The Heart of the Storm,
negative 1902, print 1914
Gelatin silver print
24.6 × 19.7 cm (9¹¹⁄₁₆ × 7¾ in.)
Gift of the Michael and
Jane Wilson Collection
94.XM.111

36

WILLIAM MORTENSEN
American, 1897–1965
The Bad Thief, 1926
Bromoil print
24.8 × 34.3 cm (9¾ × 13½ in.)
84.XP.208.188

37

ATTRIBUTED TO ROI PARTRIDGE
American, 1888–1984
Saint Anne of the Crooked Halo,
ca. 1920s
Gelatin silver print
24.4 × 19.3 cm (9⅝ × 7⅝ in.)
90.XM.58.4

38

ALFRED STIEGLITZ
American, 1864–1946
Georgia O'Keeffe, 1918
Palladium print
24.3 × 19.4 cm (9⁹⁄₁₆ × 7⅝ in.)
93.XM.25.53

39

ALFRED STIEGLITZ
American, 1864–1946
Georgia O'Keeffe, 1918
Palladium print
25.2 × 20.2 cm (9¹⁵⁄₁₆ × 7¹⁵⁄₁₆ in.)
87.XM.94.2

40

MAN RAY
American, 1890–1976
Rrose Sélavy (Marcel Duchamp),
1923
Gelatin silver print
22.1 × 17.6 cm (8¹¹⁄₁₆ × 6¹⁵⁄₁₆ in.)
84.XM.1000.80

41

MAN RAY
American, 1890–1976
Larmes (Tears), 1930–32
Gelatin silver print
22.9 × 29.8 cm (9 × 11¾ in.)
84.XM.230.2

42

MAN RAY
American, 1890–1976
The Marquise Casati with Horses, 1935
Gelatin silver print
15.4 × 10.3 cm (6¹⁄₁₆ × 4¹⁄₁₆ in.)
84.XM.1000.68

43

MAN RAY
American, 1890–1976
Le violon d'Ingres (Ingres's Violin), 1924
Gelatin silver print
29.6 × 22.7 cm (11⅝ × 8¹⁵⁄₁₆ in.)
86.XM.626.10

44

HANS BELLMER
Born Germany, 1902;
died France, 1975
Autoportrait avec la poupée (Self-Portrait with the Doll),
1934–36
Gelatin silver print
11.7 × 7.8 cm (4⅝ × 3¹⁄₁₆ in.)
84.XM.128.1

45

DORA MAAR
French, 1907–1997
Le simulateur (The Pretender), 1936
Gelatin silver print
26.6 × 21.7 cm (10½ × 8⁹⁄₁₆ in.)
84.XP.780.2

46

JACQUES-ANDRÉ BOIFFARD
French, 1902–1961
Untitled, 1930
Gelatin silver print
23.7 × 18.8 cm (9⁵⁄₁₆ × 7⅜ in.)
84.XM.1000.3

47

PAUL OUTERBRIDGE
American, 1896–1958
Woman with Claws, 1937
Carbro print
39.7 × 24.8 cm (15⅝ × 9¾ in.)
87.XM.66.2

48

PAUL OUTERBRIDGE
American, 1896–1958
Tableau Vivant, after the Painting
Lot and His Family Fleeing Sodom,
by Peter Paul Rubens, ca. 1951
Gelatin silver print
18.9 × 24 cm (7⁷⁄₁₆ × 9⁷⁄₁₆ in.)
Gift of Mark and Pam Story
97.XM.70.31

49

PHILIPPE HALSMAN
American, born Latvia, 1906–1979
Dali Atomicus, 1948
Gelatin silver print
27.9 × 35.4 cm (11 × 13¹⁵⁄₁₆ in.)
84.XP.727.12

50

KANSUKE YAMAMOTO
Japanese, 1914–1987
My Thin-Aired Room (triptych),
1956
Gelatin silver print
each approx. 25.4 × 31.1 cm
(10 × 12¼ in.)
2009.17.12-14

51

JOEL-PETER WITKIN
American, b. 1939
*Mother and Child (with Retractor,
Screaming),* 1979
Gelatin silver print
36 × 36 cm (14³⁄₁₆ × 14³⁄₁₆ in.)
84.XP.775.21

52

EIKOH HOSOE
Japanese, b. 1933
Barakei #16, from the series
Ordeal by Roses, 1962
Gelatin silver print
39.1 × 54.9 cm (15⅜ × 21⅝ in.)
2009.77.4

53

EIKOH HOSOE
Japanese, b. 1933
Barakei #39, from the series
Ordeal by Roses, 1961
Gelatin silver print
34.3 × 51.1 cm (13½ × 20⅛ in.)
2009.77.3

54

RALPH EUGENE MEATYARD
American, 1925–1972
Life of Aspersorium, 1960
Gelatin silver print
18.2 × 17.7 cm (7³⁄₁₆ × 6¹⁵⁄₁₆ in.)
Gift of Christopher Meatyard and
Jonathan Greene
2003.488.5

55

RALPH EUGENE MEATYARD
American, 1925–1972
Untitled (Cranston Ritchie), 1964
Gelatin silver print
17.2 × 17.4 cm (6¾ × 6⅞ in.)
Gift of Christopher Meatyard and
Jonathan Greene
2007.49.32

56

RALPH EUGENE MEATYARD
American, 1925–1972
*Untitled (Michael and
Christopher Meatyard),* 1966
Gelatin silver print
16.8 × 17.5 cm (6⅝ × 6⅞ in.)
Gift of Christopher Meatyard and
Jonathan Greene
2007.49.4

57

RALPH EUGENE MEATYARD
American, 1925–1972
*Lucybelle Crater and her 15 yr
old son's friend, Lucybelle Crater,*
1970-72
Gelatin silver print
17.9 × 17.6 cm (7¹⁄₁₆ × 6¹⁵⁄₁₆ in.)
Gift of Weston J. and
Mary M. Naef
98.XM.176.6

58

LUCAS SAMARAS
American, born Greece 1936
Photo-Transformation,
June 13, 1974
Polaroid print
7.6 × 7.6 cm (3 × 3 in.)
98.XM.20.3

59

LUCAS SAMARAS
American, born Greece 1936
Photo-Transformation, 1976
Polaroid print
7.6 × 7.6 cm (3 × 3 in.)
99.XM.53

60

ANDY WARHOL
American, 1928–1987
Self-Portrait (in Drag), 1981
Polaroid polacolor print
9.5 × 7.3 cm (3¾ × 2⅞ in.)
98.XM.5.2

61

ANDY WARHOL
American, 1928–1987
Helen/Harry Morales, from the
series Ladies and Gentlemen, 1974
Polaroid polacolor print
9.5 × 7.3 cm (3¾ × 2⅞ in.)
98.XM.168.2

62

SANDY SKOGLUND
American, b. 1946
Revenge of the Goldfish, 1981
Dye destruction print
70.7 × 89.2 cm (27¹³⁄₁₆ × 35⅛ in.)
Gift of John Torreano
94.XM.110

63

JO ANN CALLIS
American, b. 1940
Woman with Blue Bow, 1977
Chromogenic print
36.4 × 45.6 cm (14⁵⁄₁₆ × 17¹⁵⁄₁₆ in.)
Gift of Gay Block
2003.498.8

64

JO ANN CALLIS
American, b. 1940
Man Doing Push-Ups, 1984
Dye destruction print
61 × 76.2 cm (24 × 30 in.)
Gift of Gay Block
2003.498.18

65

JO ANN CALLIS
American, b. 1940
Performance, 1985
Dye destruction print
101.6 × 76.2 cm (40 × 30 in.)
2004.86.6

66

EILEEN COWIN
American, b. 1947
Untitled, from the series Family
Docudrama, 1980–83
Chromogenic print
48.3 × 60.3 cm (19 × 23¾ in.)
Purchased with funds provided
by the Photographs Council of the
J. Paul Getty Museum
2008.35.4

67

EILEEN COWIN
American, b. 1947
Untitled, from the series Family
Docudrama, 1980–83
Chromogenic print
48.3 × 60.3 cm (19 × 23¾ in.)
Purchased with funds provided
by the Photographs Council of the
J. Paul Getty Museum
2008.35.1

68

EILEEN COWIN
American, b. 1947
Untitled, from the series Family
Docudrama, 1980–83
Chromogenic print
48.3 × 60.3 cm (19 × 23¾ in.)
Purchased with funds provided
by the Photographs Council of the
J. Paul Getty Museum
2008.35.3

69

EILEEN COWIN
American, b. 1947
Untitled, from the series Family
Docudrama, 1980–83
Chromogenic print
48.3 × 60.3 cm (19 × 23¾ in.)
Purchased with funds provided
by the Photographs Council of the
J. Paul Getty Museum
2008.35.2

70

LIU ZHENG
Chinese, b. 1969
Peking Opera, Self-Portrait,
negative, 1997; print, 2005
Gelatin silver print
37.1 × 37 cm (14⅝ × 14⁹⁄₁₆ in.)
Gift of Dale and Doug Anderson
2008.70.1

71

YASUMASA MORIMURA
Japanese, b. 1951
*Daughter of Art History,
Theater A,* 1989
Chromogenic print with
transparent acrylic
180.3 × 246.4 cm (71 × 97 in.)
2008.52.1

72

YASUMASA MORIMURA
Japanese, b. 1951
*Daughter of Art History,
Theater B,* 1989
Chromogenic print with
transparent acrylic
180.3 × 246.4 cm (71 × 97 in.)
2008.52.2

73

TOMOKO SAWADA
Japanese, b. 1977
School Days/E, 2004
Chromogenic print
12 × 17 cm (4¾ × 6¹¹⁄₁₆ in.)
2009.47

74

CARRIE MAE WEEMS
American, b. 1953
After Manet, from the series
May Days Long Forgotten, 2003
Dye coupler print, wood
and convex glass
Diam: 84.3 cm (33³⁄₁₆ in.), framed
2006.33

75

CARRIE MAE WEEMS
American, b. 1953
May Flowers, from the series
May Days Long Forgotten, 2003
Chromogenic print
Diam: 85.1 cm (33½ in.), framed
2005.51

76

LORETTA LUX
German, b. 1969
Sasha and Ruby, 2005
Dye destruction print
23 × 32.1 cm (9¹⁄₁₆ × 12⅝ in.)
2007.36

Published by the J. Paul Getty Museum, Los Angeles
Getty Publications
1200 Getty Center Drive, Suite 500
Los Angeles, California 90049-1682
www.gettypublications.org

Gregory M. Britton, *Publisher*

Beatrice Hohenegger, *Editor*
Michelle Nordon, *Manuscript Editor*
Jeffrey Cohen, *Designer*
Stacy Miyagawa, *Production Coordinator*

Photography by Tricia Zigmund and Stacey Rain Strickler
Digital imaging by Gary Hughes
Color separations by Robert J. Hennessey and Sue Medlicott
Printed by Sing Cheong Printing Co., Ltd., Hong Kong

Library of Congress Cataloging-in-Publication Data
Garcia, Erin C.
 Photography as fiction / Erin C. Garcia.
 p. cm.
 Includes bibliographical references.
 ISBN 978-1-60606-031-5 (hardcover)
1. Staged photography—History. 2. Trick photography—
History. 3. Photography, Artistic—History. I. Title.
 TR148.G37 2010
 770—dc22
 2010006971

FRONT COVER: Jo Ann Callis, *Performance*, 1985
BACK COVER: Man Ray, *The Marquise Casati with Horses*, 1935
PAGE i: Roger Fenton, *Contemplative Odalisque*, 1858
(detail, plate 12)
PAGE ii: Julia Margaret Cameron, *The Parting of Sir Lancelot
and Queen Guinevere*, 1874 (detail, plate 22)
PAGE iii: Man Ray, *Larmes (Tears)*, 1930-32 (detail, plate 41)
PAGE iv: Eileen Cowin, *Untitled*, from the series Family
Docudrama, 1980-83 (detail, plate 67)